Christopher Brown

DUTCH PAINTING

PHAIDON **E.P.DUTTON**
Oxford New York

The author and publishers would like to thank all those museum authorities and private owners who have kindly allowed works in their possession to be reproduced. Plate 32 is reproduced by permission of the Trustees of the Wallace Collection.

Phaidon Press Limited, Littlegate House, St Ebbe's Street, Oxford
Published in the United States of America by E. P. Dutton & Co., Inc.

First published 1976

© *1976 Elsevier Publishing Projects SA, Lausanne/Smeets Illustrated Projects, Weert*

ISBN 0 7148 1691 4
Library of Congress Catalog Card Number: 76-343

Printed in The Netherlands

DUTCH PAINTING

'We arrived late at Rotterdam, there was at that time their annual mart or Faire, so furnished with pictures (especially landscips and drolleries, as they call these clownish representations) as I was amaz'd: some of these I bought and sent into England. The reason of this store of pictures, and their cheapness proceed from their want of land, to employ their stock; so as 'tis an ordinary thing to find, a common farmer lay out two or three thousand pounds in this commodity, their houses are full of them, and they vend them at their kermesses to very great gains.'

John Evelyn, who visited the Rotterdam *kermesse* on 13 August 1641, was only one of the many seventeenth-century travellers to Holland who commented with surprise on the popular market in pictures. Peter Mundy, though lacking Evelyn's high-born condescension, remarked on the same phenomenon: 'All in general striving to adorn their houses, especially the outer or street room, with costly pieces, butchers and bakers not much inferior in their shops which are fairly set forth, yea many times blacksmiths, cobblers etc. will have some picture or other by their forge and in their stall.'

Although we may wonder as to the truth of Evelyn's very English explanation of the Dutch desire for pictures (he also attributes the vast expenditure of Genoese merchants on their palaces to a lack of land in which to invest), his account not only attests the existence of a thriving trade in pictures: it also informs us that this trade was not confined – as in much of the rest of Europe – to the wealthy and the socially respectable. The artisan class bought and sold pictures, and these pictures were relatively cheap. It is worth enquiring how these conditions came about and, perhaps more specifically, what effect this popular demand had upon the kind of pictures produced in Holland during the century.

The Netherlands, the seven provinces centred on the economically dominant province of Holland (the latter included the buoyant city of Amsterdam), were enjoying a period of unparalleled prosperity in the early seventeenth century. One of the effects of the long war to gain independence from Spain, which was not formally concluded until the Treaty of Munster in 1648, was the northwards movement of the economic heart of the Low Countries. The Dutch blockaded the mouth of the river Scheldt, thus closing Spanish-held Antwerp's outlet to the sea. Antwerp's commercial supremacy then passed to Amsterdam, which became the economic centre of a nation which rivalled England as the strongest power in Northern Europe.

Dutch commercial prosperity, so bitterly defended against the English, does seem to have enriched not only the urban merchant class but a considerable number of the artisan class as well, and both social groups chose to invest excess capital in paintings. The demands of Dutch picture-buyers affected the kinds of pictures produced, and certain categories of pictures, such as Evelyn's 'drolleries', appealed particularly to the tastes of artisans.

Portraiture is, of course, a kind of painting which we should expect to flourish in these social circumstances; and it is no accident that we know more about the appearance of the seventeenth-century Dutch than about any people until the Victorians.

When Constantijn Huygens (Plate 4), the secretary of the Stadtholder of Holland, Prince Frederik Hendrick of Orange, wanted his portrait painted in 1627, the year of his marriage, he turned to one of the most fashionable portrait-painters in Amsterdam, Thomas de Keyser. Huygens was a remarkable man, a humanist in the Renaissance tradition. Between 1629 and 1631 he wrote an autobiography; and being a trained draughtsman, his remarks about contemporary painting are interesting and perceptive. Like many well-born Dutchmen, Huygens's outlook was European rather than narrowly xenophobic. He makes no distinction between painters in Holland and those in

Spanish-occupied Flanders. The painter he admires above all others, 'one of the wonders of the world', is Rubens. Huygens shows himself to be familiar with the latest developments in Italian painting, praising the Carracci above Caravaggio. As for Holland, he recognizes the merits of the older generation of artists: Goltzius and Mierevelt are singled out for praise, though he thinks that the marine painter Hendrick Vroom has been surpassed by Jan Porcellis; and it is a seascape in the style of Porcellis that hangs in his room in de Keyser's portrait. The number of good landscape painters is so great that it would fill a book, he writes. Among them he mentions Esaias van de Velde (Plate 6), one of the founders of the Dutch school of realistic landscape, and his pupil, Jan van Goyen (Plate 7). Not only are the Dutch distinguished landscapists; there are as many history painters. He praises the Utrecht school of Caravaggio followers, including Hendrick Ter Brugghen (Plate 1). It is a great tribute to the keenness of Huygens's eye that he singles out the young Leiden painters, Rembrandt and Lievens, for special mention. Rembrandt, then only in his early twenties, is described as particularly skilled in the representation of emotions, whereas Lievens excels in bold composition.

De Keyser portrayed Huygens seated at his desk as his clerk brings in a letter. Architectural drawings lying in front of him refer to his practice of that art, while the *chittarone* and the globes point to his interest in music and astronomy. The rich tapestry behind him, which appears to depict St. Francis before the Sultan, contains Huygens's arms in the border.

In 1633, six years after de Keyser painted Huygens, the retired merchant Pieter van den Broecke commissioned a portrait of himself from Frans Hals (Plate 8). The portrait, painted with all Hals's sureness of touch and strength of characterization, suggests a good-humoured, self-confident personality; an impression confirmed by van den Broecke's journal, for the frontispiece of which Hals's portrait was engraved by Adriaen Matham. Van den Broecke had enjoyed a long and successful career as a merchant, first in West Africa and later with the Dutch East India Company in Arabia, Persia and India. For his loyal service to the Company, van den Broecke was rewarded with a gold chain worth 1,200 guilders, which he proudly wears in the portrait. Hals's evocation of character in bold, firm brush-strokes is quite unlike de Keyser's approach, with its careful accumulation of detail. Hals tells us about his sitter in his choice of pose and expression, whereas de Keyser depends upon Huygens's environment to express his sitter's interests.

In his portrait of *Isabella Coymans* (Plate 25), Hals is at his most exuberant and Baroque. Her dress, with its low neckline, jewels, ribbons and bows, witnesses a liberation from the severe black and white of the traditional dress of the regent class, and must have horrified the older generation by its ostentation.

A portrait in a more serious mood, yet one which also contains a gesture which denies formality, is Rembrandt's *Agatha Bas* (Plate 14), painted in 1641. Rembrandt had come from Leiden to Amsterdam in 1631 or early in 1632, and was in constant demand as a portraitist in the city throughout the 1630s and early 1640s. His broad style superseded de Keyser's almost miniaturist technique as the most fashionable for portraits. Agatha Bas possesses neither Isabella Coymans's beauty nor her vivacity. Born in 1611, the middle daughter of the distinguished burgomaster and director of the Dutch East India Company, Dr. Dirck Jacobsz. Bas, she had married, when 27, Nicholas van Bambeeck, eleven years her senior.

In technique, the two portraits are very different. While Hals's brush delightedly sketches the highlights of satin and pearls, Rembrandt lingers, exploring the varying textures, differentiating them in half-tones and closely observing the fall of light on them.

Rembrandt used bolder, more dramatic brush-strokes and richer colour in his portrait of *Jan Six* (Plate 24), painted in 1654. Jan Six was educated at Leiden university and in 1640 sent on the Grand Tour, during the course of which he developed his interest in the Arts. On his return, after initially working unenthusiastically in the family business, he began a career as a city magistrate, which culminated

in 1691 in his appointment as burgomaster of the city. He was an avid collector of works of art, fluent in French, Italian and Spanish, and he wrote poetry. Rembrandt seems to have known him quite well in the 1640s and 1650s: there is a portrait etching (1647), an etched frontispiece for Six's play *Medea* (1648), and two drawings in Six's *Album Amicorum* (1652). Six lent Rembrandt 1,000 guilders in 1653 (an arrangement which was later to sour relations between the two men), and in the following year Rembrandt painted Six in one of the greatest of all his portraits. Six abstractedly pulls on a glove as he gazes at the spectator. He seems to pause, meditatively, before assuming his public face and going out into the city streets. His casually draped red cape is beautifully set off by the sober grey tunic with its gold buttons. The open, confident brush-strokes emphasize the spontaneity of the image.

Rembrandt's most talented pupil was Carel Fabritius, one of the most exciting and elusive figures in seventeenth-century Dutch painting. Born in Midden-Beemster in 1622, he was a pupil in Rembrandt's studio in the early 1640s. His few identified early pictures are hesitant in style: only when he went to Delft in 1650 and set up on his own did he find his feet. In the four short years between his arrival in Delft and his death in the explosion of the municipal powder dump, 'The Phoenix' (as he was called by Dirck van Bleyswijck in his 1667 history of Delft) created an original style which provides a link between Rembrandt and the Delft school of genre painting. The latter included Pieter de Hoogh, Emanuel de Witte and the greatest of all Dutch genre painters, Johannes Vermeer. In Fabritius's very fine *Self-Portrait* (Plate 20), probably painted in 1654, the year of his death, his fierce originality is evident. The stern, intense gaze, the tangled hair and the casual open-necked shirt all suggest self-conscious romantic genius. The daring placing of the head, low down on the canvas, allows Fabritius to explore the texture of the roughly plastered wall, and the shadows his own head throws upon it.

Rembrandt's so-called 'Polish Rider' (Plate 26) which dates from about 1655, is an unconventional and enigmatic portrait. The horse is gaunt, almost skeletal, rendered in broad, grey brush-strokes against a forbidding landscape which, except for a small group of men huddled around a fire, is modelled exclusively in brown tones. The picture's title was suggested not only by its presence in Poland in the eighteenth century, but also by the youth's dress: his fur cap, his *joupane* (a three-quarter length coat buttoned from neck to waist), his tight-fitting red trousers and calf-length yellow boots. He carries a war hammer, two swords, and a bow and arrows in a quiver. The horse has a flying *kutaz*, possibly made from horse-hair, attached to the bridle. The rider's determined expression and martial appearance have provoked a rash of interpretations: is he a legendary Polish hero, the Christian Knight ever watchful against the infidel, or perhaps the Prodigal Son? The truth may be more straightforward: could this not simply be a romantic portrait of one of the many Eastern European noblemen who came to Holland to study at Dutch universities? While speculation continues, the picture still witholds its secret. It remains one of Rembrandt's most fascinating masterpieces.

The group portrait is a particularly Dutch subject, and portraits of the civic guard and of guild members provided lucrative commissions for many Dutch painters. Frans Hals was for many years the favoured artist of the successive generations of the Haarlem civic guard, and he brought a wealth of experience of group portraiture to his two great late masterpieces, *The Regents* and *Regents of the Old Men's Alms House* (Plate 40), in his native town. These two great canvases, painted in about 1664, face one another today in a room in the museum named after him in Haarlem. Although he did not intend any of the personal or social satire that later critics have read into the portraits, these paintings are remarkably candid. Admittedly, Hals was destitute in the last years of his life, and from 1662 until his death in 1666 received a small pension from the town of Haarlem, but he did *not* live in the Old Men's Alms House. The sitters, however, must have known what to expect from the artist who had been portraying their fellow-townsmen for many years.

In these group portraits all inessentials are ignored as the artist, now in his eighties, concentrates the spectator's eye on the faces and, to a lesser extent, the hands of his sitters. His brush moves in short, broken strokes, stabbing the canvas with a palette restricted to ochre, red, black and white. Hals's pupil, Johannes Verspronck, brings much of his master's delicacy of tone and lightness of touch to his subtle and charming account of childhood, a girl holding a blue ostrich-feather fan (Plate 9).

Like Hals, Rembrandt painted group portraits, the most famous of which, the so-called '*Night Watch*', dates from 1642. Among the outstanding portraits in Rembrandt's late style are the so-called '*Jewish Bride*' (Amsterdam, Rijksmuseum), and the unidentified *Family Group* at Brunswick (Plate 41), painted in the mid-1660s. The palette comprises a glorious range of reds and oranges, and the texture of the surface is built up with a palette knife as well as a brush. The mood is tender, and the subtle unity of the composition is created by the mother's glance towards her eldest daughter. The father, his hand resting on his daughter's shoulder, and yet slightly removed from the group, is a stable, authoritative presence.

It was not only portraiture that flourished in Holland in the seventeenth century. Among the other secular categories of painting in constant demand were the 'landskips and drolleries' seen by Evelyn at Rotterdam.

The immediate predecessors of the great age of Dutch landscape painting gathered in Amsterdam at the turn of the century. They included the Flemings David Vinckboons, Roelandt Savery (between periods working for Rudolf II in Prague) and Gillis van Coninxloo, as well as the native Amsterdammer Pieter Lastman, Rembrandt's master. Hendrick Goltzius in Haarlem and Jacob de Gheyn in The Hague were pursuing similar aims. Coninxloo, who had arrived in Amsterdam in 1595, was the progenitor of the great art of Hercules Seghers. Born in Haarlem, Seghers was in Coninxloo's studio until his master's death in 1607.

Seghers was a truly innovative graphic artist: his landscape etchings, many of which are coloured, are among the finest productions of the century. In his paintings (Plate 2), of which only 15 or so survive, he expresses a vision that is both strange and evocative. The extensive flat landscape of Holland is modelled in subtle, striated tones of brown, green and grey. The rocky outcrops and tall firs of the Flemish landscapists have been abandoned, though Seghers's haunting views can hardly be considered strictly naturalistic. Seghers was a great inspiration to Rembrandt, who owned a number of his etchings and whose style, in his rare landscape paintings, is dependent upon him. Rembrandt's pupil, Philips Koninck, was also strongly influenced by Seghers in his panoramas over the apparently endless Dutch countryside (Plate 30), though his richer palette and the grandeur of his cloud-filled skies are marks of his own imaginative achievement.

With Seghers in the Haarlem guild were two other great innovators, Willem Buytewech, 'Geestige Willem' (witty Willem), the pioneer of elegant figure groups, and the landscapist Esaias van de Velde. Born in Amsterdam, the son of a painter and a cousin of the engraver Jan van de Velde, Esaias was probably a pupil with Seghers in the studio of Coninxloo. He went to Haarlem, no doubt attracted by the reputation of Goltzius's landscape drawings and hopeful of emulating his style. He remained there until 1618, when he moved to The Hague, where he died in 1630. He is an important figure in the development of realistic landscape: he felt particularly free to experiment in his winter landscapes, such as that of 1623 (Plate 6), a subject scene that was comparatively new. The mannerisms of Flemish landscape have disappeared in this small panel, which conveys all the crispness of an icy winter day in Holland. The figures are sketched in sure, quick strokes, the landscape evoked in pigments thinly scraped across the still-visible gesso ground. Esaias's greatest pupil was Jan van Goyen, who was in his Haarlem studio in 1616 or thereabouts: he is represented in this selection by a small seascape, monumental in its composition, painted in the year of his death, 1656 (Plate 7).

Less realistic than Esaias, yet perhaps even more charming, is Hendrick Avercamp, known as 'de stom van Kampen' because he was dumb. A mute observer, he presents without comment a winter afternoon (Plate 3), with all the townspeople, the grand and the not so grand, out on the ice beneath a breathtakingly beautiful pink sky.

Another winter scene (Plate 23) is the work of the brilliant but short-lived Isack van Ostade. He was also from the town that witnessed the birth of realistic landscape, Haarlem, and entered the guild there in 1643. He died, aged 28, only 6 years later. A pupil of his elder brother, Adriaen, he at first imitated Adriaen's peasant interiors, but in his last years painted a series of beautiful and quite original winter landscapes.

Haarlem was the home town of the greatest of all Dutch landscape painters, Jacob van Ruisdael, who entered the guild in 1648. Ruisdael was the heir to the developing tradition of realistic landscape and brought it to its finest expression. Soon after his entry into the guild, he went in 1650 on a trip with Nicholas Berchem, whom Houbraken, the eighteenth-century historian of Dutch painting, says was his great friend. They travelled across Holland to the German border and beyond, particularly to the site of the castle of Bentheim. Ruisdael sketched the site and returned to the subject in a number of paintings (Plate 12). His imagination was stirred by the drama of the scene, the medieval granite castle perched high above sheer cliffs, the whole set amid rich, green vegetation. Less innately dramatic is the imagined view (Plate 31) he painted in the late 1660s, after his move to Amsterdam in 1657. Here the Dutch countryside provides a foil to the clouds grimly lowering above, and throwing strong dark shadows across it. Constable was a great admirer of Ruisdael and profoundly influenced by him. In his third lecture to the Royal Academy, he said: 'Ruisdael delighted in, and has made delightful to our eyes, those solemn days, peculiar to his country and to ours, when without storm, large rolling clouds scarcely permit a ray of sunlight to break the shades of the forest. By these effects he enveloped the most ordinary scenes in grandeur...'

Ruisdael's most talented pupil during his Amsterdam years was Meyndert Hobbema, a native of Amsterdam, whose *Avenue at Middleharnis* in the National Gallery in London is one of the best known of all Dutch landscapes. Hobbema lacked his master's sense of the dramatic, yet his quiet wooded landscapes, such as the *Road on a Dyke* (Plate 45), painted in 1663, are evoked with an exquisite sureness of tone.

Hobbema's career is a reminder of how precarious a living was to be made from painting in Holland in the seventeenth century. He gave up painting almost entirely when, in 1668, through his marriage to the maidservant of a burgomaster of Amsterdam, he was appointed to the post of wine-gauger to the Amsterdam guild of wine-importers. It was by no means an exalted position, but it did guarantee a regular income.

Jacob van Ruisdael's travelling companion, Nicolaes Berchem, represents a different strain in Dutch landscape painting. He was one of the so-called Italianizing landscapists, some of whom had been to Italy, and all of whom interpreted the Dutch countryside in terms of Claude's Roman campagna. Born in Haarlem, the son of the still-life painter Pieter Claesz., Berchem went to Italy in 1642 with his cousin, Jan Baptist Weenix, who painted imaginary Italian seaports and still-lifes with dead game and who invariably signed his pictures 'Giovanni Battista Weenix' after his return. The landscape studies made by Berchem during his four-year stay in Rome served as material for paintings throughout his career. He was extraordinarily prolific and an influential teacher. His sketchy, highly coloured style (Plate 46) seems almost to foreshadow the Rococo and was much appreciated in eighteenth-century France when, for example, Boucher, who owned several pictures by Berchem, was influenced by him.

Berchem worked in Haarlem and after 1677 in Amsterdam, but the principal centre for Italianizing landscape painting was Utrecht. Its most important figure

was Jan Both, who lived in Rome in the second half of the 1630s, and in whose work the Dutch woods are flooded with golden Italian light and peopled by Arcadian shepherds and Greek gods. Aelbert Cuyp, who worked in his home town of Dordrecht, never visited Italy, but his study of Both's Italianate views caused him to abandon his early van Goyenesque style. His mature style (Plate 44) is characterized by the fall of rich sunlight, and the solidity and simplicity of his forms.

The Dutch taste for pictures which, in differing degrees, represented the physical world extended beyond landscape as such. The taste for marine seascapes was widespread, and they were collected both by merchants, such as Pieter van de Broecke, and cultivated humanists, such as Constantijn Huygens. Jan Porcellis, a picture in whose style hangs at the back of Huygens's study in de Keyser's portrait, entered into a contract with the Antwerp cooper, Adriaen Delen, in 1615. Porcellis agreed to paint seascapes on forty boards supplied to him by Delen. The cooper was to supply him with the paints, give him an advance of 30 guilders and pay him 15 guilders a week while he was working on the pictures. Porcellis would paint two seascapes a week which Delen would sell, the profits to be split two ways after Delen had subtracted 40 guilders for paints and 160 for other materials and frames. The whole work was to take twenty weeks, during which time Delen was to arrange for Porcellis to have a pupil to assist him. This kind of contract, into which many Dutch artists entered in order to secure a regular income, was not of a kind to encourage experimentation and imaginative flights.

Marine subjects were also painted by many landscape painters, such as Jan van Goyen (Plate 7) and Aelbert Cuyp (Plate 34), who depicted the mouth of the river Maas (Meuse) at Dordrecht. The late evening sun falls on the squat tower of the Grote Kerk, a familiar landmark in Cuyp's many views of his hometown.

Jan van de Cappelle, on the other hand, devoted his attention almost exclusively to marine subjects. In his classically balanced compositions (Plate 35), he brings a dignity and sense of seriousness to his subjects, which suggest comparison with Ruisdael's landscapes. An Amsterdammer, van de Cappelle's style is based on that of Simon de Vlieger, who came to the city from Rotterdam. Van der Cappelle's father owned a dyeing business and the artist seems to have worked in this trade too. He was a man of some wealth, and amassed a fascinating collection of paintings.

Willem van de Velde the Younger was a pupil of Simon de Vlieger, after having trained with his father, Willem the Elder. His brother Adriaen was an Italianizing landscape painter. Both Willems, father and son, painted seascapes exclusively, but Willem the Younger concentrated more and more on 'portraits' of individual ships and on naval engagements. After the social and economic disruption brought about by Louis XIV's invasion of Holland in 1672, the elder van de Velde decided to try and make his living in England, or, if that failed, in Italy. He and his son came to London late in that year, and soon afterwards the two painters were taken into the service of the king, Charles II. The document of their appointment records that each was to be paid a salary of a hundred pounds a year, in addition to payments for their pictures, the father for 'taking and making Draughts of seafights' and the son for 'putting the said Draughts into colours'. Sadly, the move to England had a deleterious effect on the young van de Velde's production, which becomes dependent on stale mannerisms. Rarely did he reproduce for his royal patron the quality seen in his early work from the Amsterdam years, as, for example in *The Cannon Shot* (Plate 28).

Dutch painters also turned their attention to the beauty of their towns. The first artist to specialize in town views was Jan van der Heyden, who lived in Amsterdam. 'He painted', wrote Houbraken, the eighteenth-century critic, 'every brick in his buildings . . . so precisely that one could clearly see the mortar in the joints, and yet his work did not lose in charm or appear hard if one viewed·the pictures as a whole from a certain distance.' This painstaking technique, perhaps developed during his apprenticeship to a glass painter, can be seen in his view of the small town of Veere (Plate 10) in Zeeland, on the strait between Walcheren and Noord

Beveland. Van der Heyden painted more than a hundred identified places in Holland, as well as views of Brussels and Cologne. From the end of the 1660s he devoted a great part of his time to lucrative schemes for improving street-lighting and fire-fighting in Amsterdam.

The Haarlem painter Pieter Saenredam brought a cooler and more dispassionate eye to his accounts of Dutch buildings. Trained in the studio of the Caravaggesque painter Frans de Grebber, he entered the Haarlem guild in 1623 and, according to his first biographer Cornelis de Bie, from 'about 1628 devoted himself entirely to painting perspectives, churches, halls, galleries, buildings and other things from the outside as well as the inside, in such a way, after life, that their essence and nature could not be shown to greater perfection. . .'. Saenredam's view of *St. Mary's Square and St. Mary's Church at Utrecht* (Plate 11) was painted in 1663, two years before his death. The elaborate preliminary drawing, executed with the aid of measurements and plans, is dated 1636. Despite this gap of a quarter of a century, Saenredam made few changes when he came to paint: figures were moved, two trees and a small building omitted, and the tower heightened. Saenredam's exacting method might suggest the dullness of architectural draughtsmanship. However, when he came to transfer his drawings to panel, his exquisite palette and his feeling for texture produced a series of delicate, understated masterpieces.

Saenredam painted many church interiors, and particularly a number of St. Bavo at Haarlem, where he is buried. This church was also a favourite of the younger Emanuel de Witte, who came from Alkmaar to work in Delft and later in Amsterdam. During his years in Delft de Witte would have become familiar with the work of Carel Fabritius, which influenced his own style. From 1650, de Witte, who had previously painted a number of subject pictures and portraits, concentrated on church interiors. Houbraken informs us that he was 'famed for his knowledge of perspective', but architectural accuracy is not his first concern. The figures placed in the foreground of his 1668 *Interior of a Protestant Gothic Church* (Plate 38) idly stroll and talk, breaking up the severity of the composition. The gravedigger's tools, the brass candelabra, the organ case and the armorials are clearly described, while the whitewashed walls and pillars are enlivened by the strong fall of sunlight. De Witte's colours are far warmer and richer than Saenredam's, and his technique closer to genre painting than to architectural draughtsmanship.

Just as sixteenth-century Flemish landscape painting was the forcing-ground for Dutch landscape of the seventeenth century, and Flemish perspective studies the parent of Dutch townscape, so the flower paintings of Jan Brueghel and his contemporaries, larded with symbol and allegory, were the predecessors of Dutch realistic still-life painting. Sometimes emblems persist or new ones are introduced, but Willem Kalf's *pronkstilleven* (*pronk* means ostentatious display) have the purpose merely of recording, in elegant groupings, rare and beautiful objects which were treasured by the wealthy merchant class of Amsterdam. After settling in the city in 1653, Kalf catered to this taste in a series of remarkable paintings, which seem to apply Vermeer's palette and technique to still-life subjects. In *Still-Life with Nautilus Cup* (Plate 29), the china bowl, nautilus cup, peeled lemon and rich carpet are all meltingly painted with highlights of pure pigment. Goethe wrote of a still-life by Kalf that the picture showed 'in what sense art is superior to nature and what the spirit of man imparts to objects when it views them with creative eyes. There is no question, at least there is none for me, if I had to choose between the golden vessels and the picture, that I would choose the picture.'

Jan van Huijsum's *Hollyhocks and other Flowers in a Vase* (Plate 47) was painted early in the eighteenth century, yet remains in the tradition of the previous century: it still has the rich tonalities of his work prior to the 1720s, when he began to paint more and more elaborately contrived flowerpieces in a light, almost pastel, palette.

The pictures that Evelyn calls 'drolleries', dismissing them as 'clownish representations',

are pictures that we should describe with the French word 'genre', meaning 'a kind' or 'a sort'. The word is used today to cover a wide range of figure paintings, often on a small scale, depicting scenes from everyday life. Evelyn's 'drolleries', we may imagine, resembled Adriaen van Ostade's peasant interiors rather than Vermeer's elegant rooms. The origin of this use of the word 'genre' is obscure and was certainly not employed by the seventeenth-century Dutch, who had words to describe different types of genre scenes. In discussing these pictures, one note of caution is necessary: many of the subjects which we think of as showing scenes from everyday life may well have possessed emblematic, or moralistic, significance for their seventeenth-century audience. For example, the subject of Ter Borch's *A Boy Ridding his Dog of Fleas* (Plate 33) was often used in series of 'The Five Senses' to signify touch. Similarly, Frans van Mieris's *A Lady Looking into a Mirror* (Plate 48) belongs to a tradition of representations of *Superbia*, the sin of pride. However, as with still-lifes, many of these connotations may have dropped away even during the seventeenth century as the subject came to stand simply for itself.

The greatest of all Dutch genre painters, Johannes Vermeer, began his career as a painter of large-scale figure scenes which suggest familiarity with the work of the Utrecht followers of Caravaggio. Little is known of Vermeer's life and the chronology of his small *oeuvre* is confused. He was born in Delft in 1632 and entered the guild in 1653, the year of his marriage to the daughter of a Roman Catholic family. He may have become a Roman Catholic himself at this time. Vermeer was elected to hold office in the guild on four occasions, which suggests that he was regarded with respect by his fellow-guildsmen. As is the case with many Dutch artists, we cannot be sure to what extent he was dependent on the sale of his paintings for his living: he was also active as an art dealer and, after his father's death, ran the family inn. He was continually in financial difficulties and a few months after his death in 1675, his widow applied for a writ of insolvency. She claimed that the French invasion had brought about a decline in the demand for pictures. Foreign collectors passing through Delft are known to have visited Vermeer's studio: for example, the Frenchman Balthasar de Monconys, in 1663, who thought his work overpriced. His paintings seem to have fetched reasonable prices (one was bought for 600 guilders), but they were far below the prices paid to the fashionable artists in Amsterdam.

The Procuress, in Dresden, is dated 1656. In the picture of *A Girl Reading at an Open Window* (Plate 18), in the same gallery, probably painted about two years later, the artist has simplified his subject-matter. He concentrates on the solitary, self-absorbed figure who reads a letter, no doubt from an absent lover. The artist enjoys his own virtuosity: her reflection in the window, the foreground still-life, the illusionistic curtain which cuts off the right-hand side of the room, all are rendered with self-conscious skill. The paint is thickly applied, the brush loaded with pure pigment to touch in the highlights on the fruit, the curtain and the girl's braided hair. It is not known who was Vermeer's master, but his early style would suggest a link with Rembrandt's talented pupil, Carel Fabritius, who lived and worked in Delft; at the time of his death, Vermeer owned three pictures by Fabritius.

The date on *The Geographer* (Plate 43), 1669, was probably added after Vermeer's lifetime, but may well be accurate. Its companion, *The Astronomer*, in a private collection in Paris, is genuinely dated 1668. The subject of a scholar at work is a familiar one for Dutch artists: Rembrandt treated it a number of times, notably in an etching of the early 1650s known as *Dr Faustus*. Rembrandt's interpretation is mystical and dramatic, with suggestions of alchemy, dark arts and cabalistic symbols: Vermeer's is rational and contemporary. It shows a seventeenth-century scientist, his head raised from his maps for a moment, dividers in hand. It reminds us of the scientific temper of the age, of the great advances made in the description of the physical world. (Anthony van Leeuwenhoeck, the great Dutch biologist who had a chair at the university of Leiden, was appointed executor of Vermeer's bankrupt

estate, and may have been an acquaintance of the artist.)

In *The Music Lesson* (London, Royal Collection), probably painted at about the same time as *The Geographer*, the self-conscious virtuosity is still evident in the use of steep perspective. Vermeer has placed the figures at the far end of the room, and draws our attention to the mullioned windows, the fall of light on the tiled floor, the white Delftware jug, the table, chair and cello, before our eye eventually reaches the couple engaged in one of those speechless musical courtships so favoured by Dutch genre painters. Here the colours are rich, far warmer than the almost pastel tones of the works of the mid-1660s, like the Mauritshuis *Head of a Girl*, and the paint applied more thinly and evenly than in the Dresden *Girl at a Window*. In the *A Painter in his Studio* (Plate 42) we may find the composition over-complicated, even muddled. The palette is again rich and the paint applied to almost porcelain smoothness. In the inventory made after his death, Vermeer's widow entitled the picture *De Schilderkonst* (The Art of Painting), and so it seems unlikely to represent Vermeer himself at work. The artist is portrayed in archaic 'Burgundian' dress, and the model, wearing a laurel wreath and carrying a book and the trumpet of Fame, is Clio, the muse of History.

Pieter de Hoogh was an exact contemporary of Vermeer, born only three years earlier, in 1629, and entering the Delft guild two years after him in 1655. No direct relationship between the two artists has been traced, but it would seem that de Hoogh's contact with the vigorous art of Carel Fabritius and other Delft artists caused him to abandon the barrackroom scenes, in the manner of the Amsterdam painters Codde and Duyster, of his early period. Instead he took for his subjects scenes from the comfortable daily life of the Delft middle classes. *The Courtyard of a House in Delft* (Plate 19), dated 1658, is one of this series of domestic *vignettes*, which he painted during the 1650s, before his move to Amsterdam. It employs his characteristic device of a view opened up within the picture. Here we look through an archway and a passage, past the standing woman, into a distant garden flooded with sunlight. Balancing this light-filled vista is the dark background behind the figure of a maid at whom the child trustingly glances. The perspective of the brick courtyard and the still-life of the brush and bucket add to the visual complexity of the composition.

In the early 1660s de Hoogh moved from Delft to Amsterdam. His earliest pictures after the move still possess the harmonious colouring and strength of composition of his Delft paintings. In *At the Linen Closet* (Plate 39) of 1663, a housewife's domestic routine is the uneventful subject: again the artist has included a deep vista, this time through the front of the house onto the canal and the houses opposite. Later in the 1660s de Hoogh's patrons were grander; and a loss of simplicity in his interiors coincides with a falling-off in the quality of the pictures themselves. In de Hoogh's case, this is particularly marked, and the interiors of the late 1660s onwards suffer from acid colours and clumsy figure-drawing. It is the series of carefully composed and subtly coloured masterpieces from his Delft years that entitles de Hoogh to his place among the greatest of Dutch genre painters.

Thoré-Bürger, the nineteenth-century French critic, placed Gerard Ter Borch second only to Rembrandt in the pantheon of seventeenth-century Dutch artists, and certainly his delicate portraits and domestic interiors combine psychological nuance with a quite extraordinary technical virtuosity in the treatment of texture, whether of hair, skin, fur or satin. Born in Zwolle in 1617, and trained in the studio of his father and in that of the landscapist Pieter Molijn at Haarlem, Ter Borch travelled extensively in Europe, visiting England, France, Spain and Italy, and in 1648 was in Münster to record the signing of the peace treaty with Spain. For his small painting of the swearing of the oath of ratification, now in the National Gallery, London, he asked 6,000 guilders, four times the sum Rembrandt received for *The Night Watch*. In 1654 Ter Borch married and settled in the provincial northern town of Deventer, and from these later years (he died there in 1681) date the interior scenes which is the highest point of his achievement. *A Boy Ridding*

his Dog of Fleas (Plate 33) was painted soon after Ter Borch's arrival in Deventer, in about 1655, and his treatment of this mundane subject in muted tones is characteristic of his understated art. The boy's discarded homework is a charmingly observed human detail.

Ter Borch had few pupils, but one, Caspar Netscher, profited well from his apprenticeship at Deventer. He successfully adopted his master's technique in the painting of varying textures, and in his *The Lace-Maker* (Plate 32) of 1664 achieves a subtle and original design. The engraving tacked to the bare wall suggests that an interest in the visual arts existed even at this level of society. Netscher moved to The Hague in 1662, and devoted his talents to portraits of members of the court circle.

Gabriel Metsu was a pupil of Gerrit Dou (who himself had been Rembrandt's first pupil) in Leiden but, like Pieter de Hoogh, he gravitated to Amsterdam, where he had settled by 1657. His pictures have a richness of surface which contrasts with his master's highly wrought miniaturist panels, and he is the most underrated of the Dutch genre painters. His colours are rich and his harmonies resonant. In *The Sick Child* (Plate 15), painted in about 1660, the figures, surely based on a Virgin and Child composition, are brilliantly characterized, the child perhaps petulant rather than sick. The group may recall Vermeer, yet the colours are far richer, the shadows stronger and the brushwork more open.

Another pupil of Gerrit Dou was Frans van Mieris the Elder, who was the heir to the tradition of 'fine painting' in Leiden, remaining there throughout his working life. Like Dou, his work was popular and expensive. He interpreted and adapted many of Dou's designs, but in a picture such as *A Lady Looking into a Mirror* (Plate 48), he is wholly original, rivalling even Ter Borch in his treatment of rich materials. The image no doubt belongs to the late medieval tradition of representations of *Superbia* (Pride), but we may suppose that the artist intended us to admire rather than condemn.

Jan Steen is irrepressible and unpredictable in his art, as he was in his life. His *œuvre* is huge and varied, ranging from small delicate landscapes like the *Skittle Players outside an Inn* (Plate 22) to large figure compositions like *The Village School* (Plate 17). His pictures also vary enormously in quality, suggesting that he was not above hackwork in order to supplement his income.

Born in Leiden, Steen entered the university in 1626 but was soon on the move, working in the studios of Nicholas Knupfer at Utrecht, Adriaen van Ostade at Haarlem and Jan van Goyen, whose daughter he married in 1649, in The Hague. He continued his peripatetic existence, combining the profession of painter with that of tavern-keeper, until he finally settled in his home town in 1670, where he died nine years later.

The Village School (Plate 17) reveals Steen's debt to Adriaen van Ostade's peasant interiors. The rowdy class-room, presided over by the kindly schoolmistress and the absurd schoolmaster, and the children represented in every attitude from the studious to the violent, show his imagination at its richest. By contrast, the *Skittle Players outside an Inn* (Plate 22), painted in the early 1660s, recalls the pleasures of a summer afternoon. It is a small, glittering panel, painted in sharp blues and greens, with mottled sunlight filtering through the trees.

One group of pictures represented in the present selection remains to be mentioned – paintings of religious subjects. As we can plainly see in the paintings of church interiors by Saenredam and de Witte, the traditional source of patronage for religious paintings – the church itself – had almost completely disappeared with the whitewashing of church walls by the Calvinists. Despite Erasmus's vacillations, many Netherlanders were early and enthusiastic converts to Protestantism. The long war with Roman Catholic Spain encouraged identification of the cause of freedom with Protestantism, and more particularly with Calvinism, the extreme form of Protestantism formulated by John Calvin in Geneva. Calvin's reading of the Old Testament led him to condemn any form of religious imagery, including painting, as Popish idolatry,

and his teaching provided the pretext for the great iconoclasm which swept the Netherlands in 1566, and for further outbreaks in later years.

However, the triumph of Calvinism was not absolute, and several artists were commissioned to paint large-scale religious works, particularly the group of followers of Caravaggio working at Utrecht in the early part of the century. Prominent among this group were Gerrit van Honthorst and Hendrick Ter Brugghen. Honthorst spent ten years in Italy where he was known as *Gherardo della Notte*. His fellow Utrecht Caravaggist, Hendrick Ter Brugghen, was a far more sensitive and original painter, interpreting the style of Caravaggio and his Italian followers in a refined and personal idiom. He returned from Rome, where he had lived for a decade, in 1614 and worked in his native Utrecht until his death, fifteen years later. His *Flute Player* (Plate 1), one of a pair now at Kassel, displays virtuoso treatment of the drapery in the sleeve of the boy, who wears the jacket of an Italian *bravo*. Caravaggio's use of individual models in religious paintings, and his dramatic *chiaroscuro*, were adopted and developed by these Utrecht artists. Rembrandt looked carefully at their work, particularly in the 1630s when in pictures like the Frankfurt *Blinding of Samson* and the London *Belshazzar's Feast* he was experimenting with large-scale religious painting. However, as the demand for this kind of full-blooded Baroque *tour de force* declined, Rembrandt evolved a new kind of religious painting, in small pictures which express his deeply-felt response to Biblical events. A beautiful early example is the *Jeremiah Lamenting the Destruction of Jerusalem* (Plate 5), painted in 1630. The picture belongs to a group of studies of elderly people from his early years: the burning city and the soldiers in the gateway are little more than a backdrop to the figure of the sorrowing old man, who rests his elbow on his own book of prophecies (the inscription 'Bibel' was added by a later painter). It is a moving image of the inevitability of human folly, painted in strong contrasts of light and dark, and in a painstakingly detailed technique which recalls the artist's debt to his master, Pieter Lastman.

In *Christ and the Woman Taken in Adultery* (Plate 13) of 1644, the figures are dwarfed by the massive temple, their drama heightened by a fall of light which suffuses the rich colour of the altar and the robes of the priests. This account of Christ's forgiveness of the adulteress reveals Rembrandt's great gifts as a colourist, an aspect of his art which is often forgotten. The panel is in some senses a transitional one, the general composition and the splendour of the temple, so enthusiastically detailed by the painter, contrasting with the simplicity of the foreground scene, which is treated in the broader style of his later work.

Rembrandt's return to a large format for religious paintings a decade later no doubt reflects the liberalization of the religious situation in Holland. Although not meant for churches, these suggest that patrons now felt that to possess a large religious picture would not anger their Calvinist neighbours. One of Rembrandt's greatest religious works is the *Jacob Blessing the Children of Joseph* (Plate 27), painted in 1656 during one of the most fiercely creative periods of his career. Joseph tries to guide his father's hand to the head of the first-born, but Jacob's right hand rests on the blond head of the younger child, Ephraim, to whom the Gentiles trace their ancestry. The elder boy, Manasseh, who is small and dark, is blessed with the left hand. The submissive gesture of Ephraim's crossed hands, Joseph's tender regard for his father, Manasseh's intense gaze towards his brother, all are painted in strong, broad strokes. The unusual presence of Asenath, Joseph's wife, also in an attitude of submission, strengthens and balances the composition.

Dutch painting closely reflects Dutch society: not merely in temporary fashions but in more profound ways – for example, in the importance placed on the family and on groups such as the guilds and the civic guards; in the pride taken in the countryside and in the towns; and in the importance of the sea, on which the nation was dependent for its economic well-being. The Dutch of all social classes were eager to adorn their houses with pictures, or, as in the case of Netscher's

13

Lace-Maker, with prints. The existence of numerous local schools, far from fashionable Amsterdam and the court-dominated Hague, attests the existence of a mass market for pictures. Paintings were cheap, and many artists had to combine their work with other employment, while others found themselves in dire financial straits. Rembrandt himself died bankrupt. Paintings must have been largely considered as domestic furniture, and painters consequently regarded as craftsmen, like carpenters and weavers.

Yet despite the special features of the Dutch market for pictures, and the low social status of the painter in Dutch society, we must not imagine that Dutch painting was entirely cut off from developments in the rest of Europe. This is a misconception that even the great Dutch historian, Johan Huizinga, expressed in his essay on Dutch seventeenth-century civilization, written in the patriotic days of the German occupation. Art has its own self-perpetuating history, regardless of the demands of patronage. Ruisdael's lowering skies and Vermeer's billowing curtains are as much a part of the European movement we call the Baroque as Rubens's altarpieces or Lanfranco's frescoes. The scale is different, but the 'domestic Baroque' of the Dutch painters reveals a similar delight in dynamic, swirling compositions and rich colour, and possesses an equal emotional intensity.

List of Plates

1. HENDRICK TER BRUGGHEN (1588–1629): *Thè Flute Player*. 1621. Canvas, 70 × 55 cm. Kassel, Gemäldegalerie.

2. HERCULES SEGHERS (1589/90–after 1633): *A River Valley with a Group of Houses*. About 1625. Canvas, 70 × 86·6 cm. Rotterdam, Boymans-van Beuningen Museum.

3. HENDRICK AVERCAMP (1585–1634): *A Scene on the Ice near a Town*. About 1610. Wood, 58 × 89·8 cm. London, National Gallery.

4. THOMAS DE KEYSER (1596/7–1667): *Constantijn Huygens and his Clerk*. 1627. Wood, 92·4 × 69·3 cm. London, National Gallery.

5. REMBRANDT VAN RIJN (1606–69): *Jeremiah Lamenting the Destruction of Jerusalem*. 1630. Canvas, 58 × 46 cm. Amsterdam, Rijksmuseum.

6. ESAIAS VAN DE VELDE (c.1590–1630): *A Winter Landscape*. 1623. Wood, 25·9 × 30·4 cm. London, National Gallery.

7. JAN VAN GOYEN (1596–1656): *Das Haarlemer Meer*. 1656. Canvas, 39 × 54 cm. Frankfurt, Städelsches Kunstinstitut.

8. FRANS HALS (c.1580–1666): *Pieter van den Broecke*. About 1633. Canvas, 71·2 × 61 cm. London, Kenwood House, Iveagh Bequest.

9. JOHANNES CORNELISZ. VERSPRONCK (1597–1622): *Portrait of a Girl in a Blue Dress*. 1641. Canvas, 82 × 66·5 cm. Amsterdam, Rijksmuseum.

10. JAN VAN DER HEYDEN (1637–1712): *Approach to the Town of Veere*. About 1665. Wood, 45·7 × 55·9 cm. London, Royal Collection (reproduced by gracious permission of Her Majesty the Queen).

11. PIETER JANSZ. SAENREDAM (1597–1665): *St. Mary's Square and St. Mary's Church at Utrecht*. 1663. Wood, 110·5 × 139 cm. Rotterdam, Boymans-van Beuningen Museum.

12. JACOB VAN RUISDAEL (1628/9–82): *The Castle at Bentheim*. 1651. Canvas, 99·7 × 82·6 cm. Norfolk, Private Collection.

13. REMBRANDT VAN RIJN (1606–69): *Christ and the Woman Taken in Adultery*. 1644. Wood, 83·8 × 65·4 cm. London, National Gallery.

14. REMBRANDT VAN RIJN (1606–69): *Agatha Bas*. 1641. Canvas, 105·4 × 83·8 cm. London, Royal Collection (reproduced by gracious permission of Her Majesty the Queen).

15. GABRIEL METSU (1629–67): *The Sick Child*. About 1600. Canvas, 33·2 × 27·2 cm. Amsterdam, Rijksmuseum.

16. MICHIEL SWEERTS (1624–64): *The Drawing Class*. About 1650. Canvas, 76·5 × 109·9 cm. Haarlem, Frans Hals Museum.

17. JAN STEEN (1625/6–79): *The Village School*. About 1670. Canvas, 83·8 × 109·3 cm. Edinburgh, National Gallery of Scotland (on loan from the Duke of Sutherland).

18. JOHANNES VERMEER (1632–75): *A Girl Reading at an Open Window*. About 1658. Canvas, 85·7 × 64·5 cm. Dresden, Gemäldegalerie.

19. PIETER DE HOOGH (1629–after 1684): *The Courtyard of a House in Delft*. 1658. Canvas, 73·5 × 60 cm. London, National Gallery.

20. CAREL FABRITIUS (1622–54): *Self-Portrait*. About 1654. Wood, 33·5 × 27 cm. Rotterdam, Boymans-van Beuningen Museum.

21. REMBRANDT VAN RIJN (1606–69): *Portrait of Titus*. 1655. Canvas, 77 × 63 cm. Rotterdam, Boymans-van Beuningen Museum.

22. JAN STEEN (1625/6–79): *Skittle Players outside an Inn*. About 1662–3. Wood, 33·5 × 27 cm. London, National Gallery.

23. ISACK VAN OSTADE (1621–49): *A Winter Scene*. About 1645. Wood, 48·8 × 40 cm. London, National Gallery.

24. REMBRANDT VAN RIJN (1606–69): *Jan Six*. 1654. Canvas, 112 × 102 cm. Amsterdam, Six Collection.

25. FRANS HALS (c.1580–1666): *Isabella Coymans*. Detail. About 1650–2. Canvas. Paris, Baronne Edouard de Rothschild.

26. REMBRANDT VAN RIJN (1606–69): *'The Polish Rider'*. About 1655. Canvas, 114·9 × 135 cm. New York, Frick Collection.

27. REMBRANDT VAN RIJN (1606–69): *Jacob Blessing the Children of Joseph*. Canvas, 117·5 × 210·5 cm. Kassel, Gemäldegalerie.

28. WILLEM VAN DE VELDE (1633–1707): *The Cannon Shot*. About 1670. Canvas, 78·5 × 67 cm. Amsterdam, Rijksmuseum.

29. WILLEM KALF (1619–93): *Still-Life with Nautilus Cup*. 1662. Canvas, 79 × 67 cm. Lugano-Castagnola, Thyssen-Bornemisza Collection.

30. PHILIPS KONINCK (1619–88): *An Extensive Landscape with a Road by a Ruin*. 1655. Canvas, 137·4 × 167·7 cm. London, National Gallery.

31. JACOB VAN RUISDAEL (1628/9–82): *A Landscape with a Ruined Castle and a Church*. About 1665–70. Canvas, 109·2 × 146·1 cm. London, National Gallery.

32. CASPAR NETSCHER (1639–84): *The Lace-Maker*. 1664. Canvas, 33 × 26·6 cm. London, Wallace Collection.

33. GERARD TER BORCH (1617–81): *A Boy Ridding his Dog of Fleas*. About 1665. Canvas, 35 × 27 cm. Munich, Bayerische Staatsgemäldesammlungen.

34. AELBERT CUYP (1620–91): *View of Dordrecht*. About 1655. Canvas, 97·8 × 137·8 cm. London, Kenwood House, Iveagh Bequest.

35. JAN VAN DE CAPPELLE (*c.*1623/5–79): *A Shipping Scene with a Dutch Yacht Firing a Salute*. 1650. Canvas, 85·5 × 114·5 cm. London, National Gallery.

36. GERARD TER BORCH (1617–81): *A Dancing Couple*. About 1662. Canvas, 76 × 68 cm. Polesden Lacey, The National Trust.

37. JAN STEEN (1625/6–79): *The Morning Toilet*. 1663. Wood, 65·2 × 53 cm. London, Royal Collection (reproduced by gracious permission of Her Majesty the Queen).

38. EMANUEL DE WITTE (1616/18–92): *Interior of a Protestant Gothic Church*. 1668. Canvas, 78·5 × 111·5 cm. Boymans-van Beuningen Museum.

39. PIETER DE HOOGH (1629–after 1684): *At the Linen Closet*. 1663. Canvas, 72 × 77·5 cm. Amsterdam, Rijksmuseum.

40. FRANS HALS (*c.*1580–1666): *Regents of the Old Men's Alms House*. About 1664. Canvas, 176·5 × 256 cm. Haarlem, Frans Hals Museum.

41. REMBRANDT VAN RIJN (1606–69): *Family Group*. About 1666–8. Canvas, 126 × 167 cm. Brunswick, Herzog Anton Ulrich Museum.

42. JOHANNES VERMEER (1632–75): *A Painter in his Studio*. About 1666. Canvas, 130·2 × 109·9 cm. Vienna, Kunsthistorisches Museum.

43. JOHANNES VERMEER (1632–75): *The Geographer*. 1669. Canvas, 53 × 46·4 cm. Frankfurt, Städelsches Kunstinstitut.

44. AELBERT CUYP (1620–91): *River Landscape*. About 1655–60. Canvas, 123 × 241 cm. Mount Stuart, Marquess of Bute.

45. MEYNDERT HOBBEMA (1638–1709): *Road on a Dyke*. 1663. Canvas, 108 × 128·3 cm. Blessington, Ireland, Sir Alfred Beit, Bt.

46. NICOLAES BERCHEM (1620–83): *Peasants with Cattle by a Ruined Aqueduct*. About 1658. Canvas, 47 × 38·7 cm. London, National Gallery.

47. JAN VAN HUIJSUM (1682–1749): *Hollyhocks and other Flowers in a Vase*. About 1710. Canvas, 62·1 × 52·3 cm. London, National Gallery.

48. FRANS VAN MIERIS (1635–81): *A Lady Looking into a Mirror*. About 1662–3. Wood, 59·2 × 31·6 cm. Munich, Alte Pinakothek.

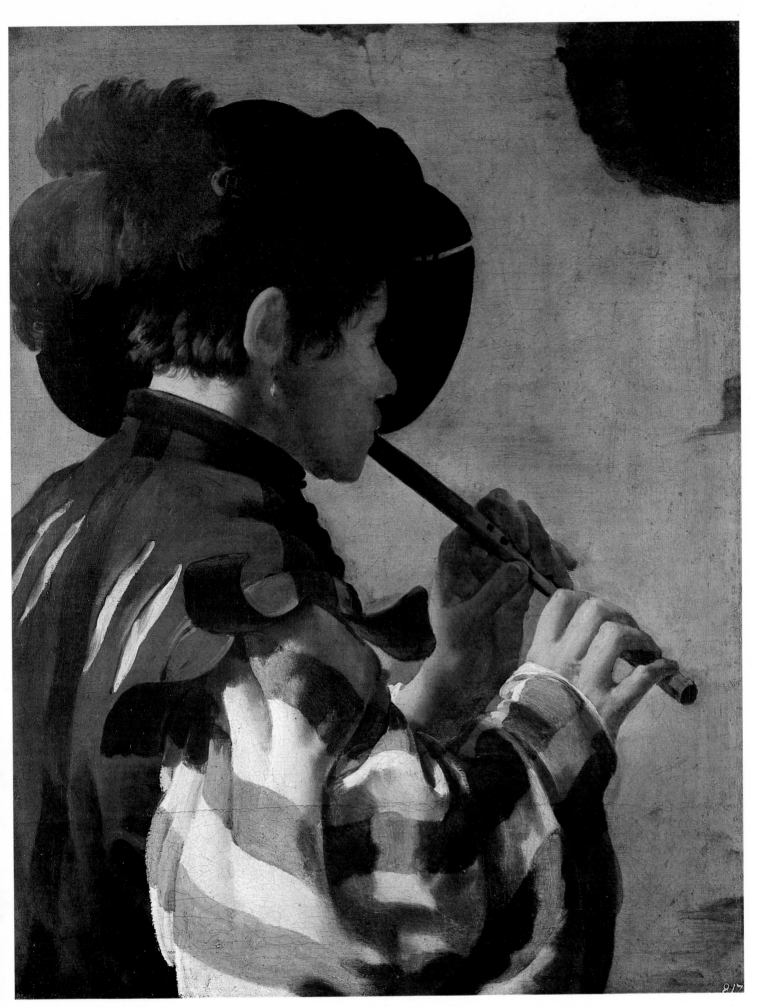

I. HENDRICK TER BRUGGHEN (1588–1629): *The Flute Player*. 1621. Kassel, Gemäldegalerie

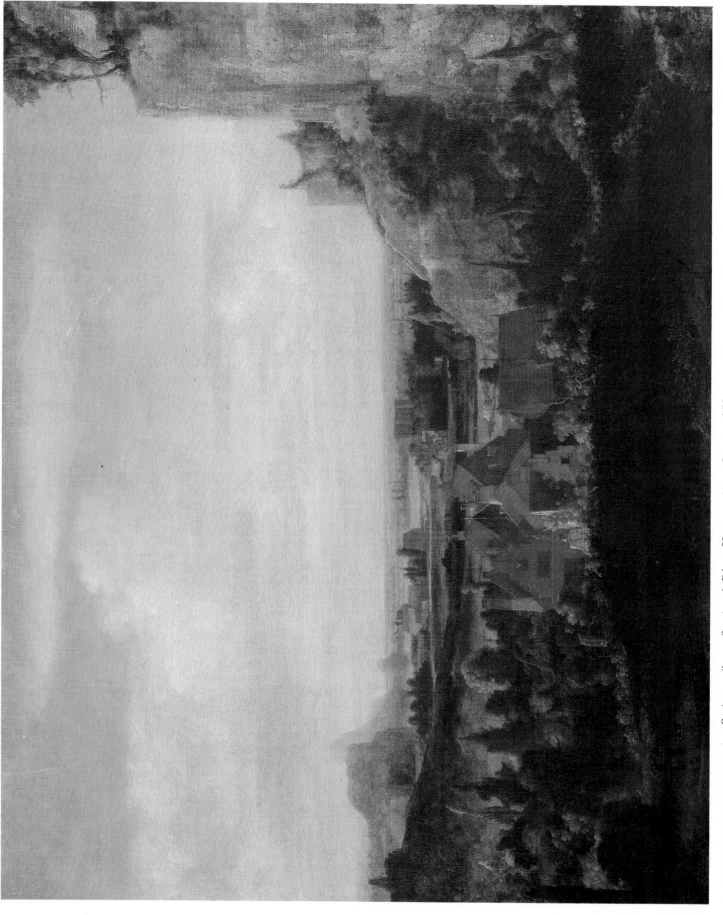

2. HERCULES SEGHERS (1589/90–after 1633) : *A River Valley with a Group of Houses*. About 1625. Rotterdam, Boymans-van Beuningen

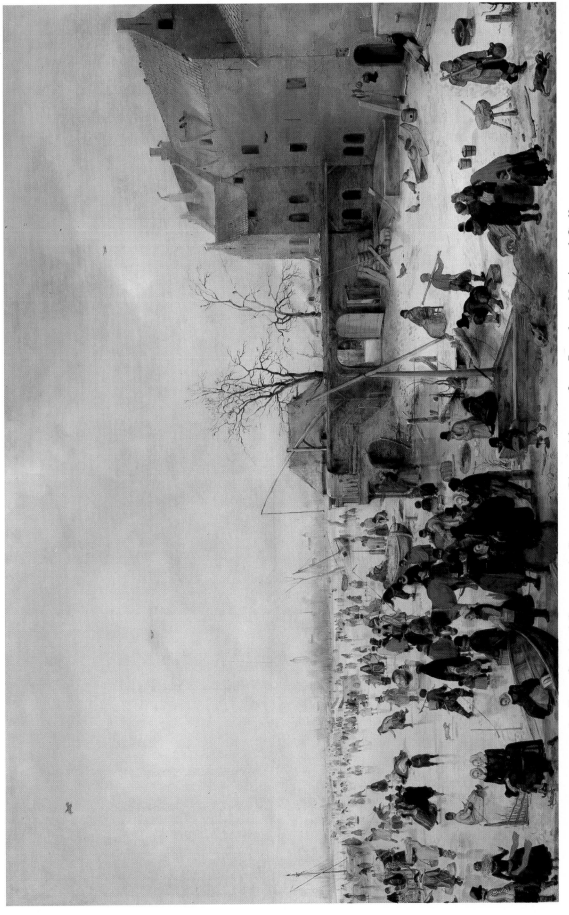

3. HENDRICK AVERCAMP (1585–1634): *A Scene on the Ice near a Town*. About 1610. London, National Gallery

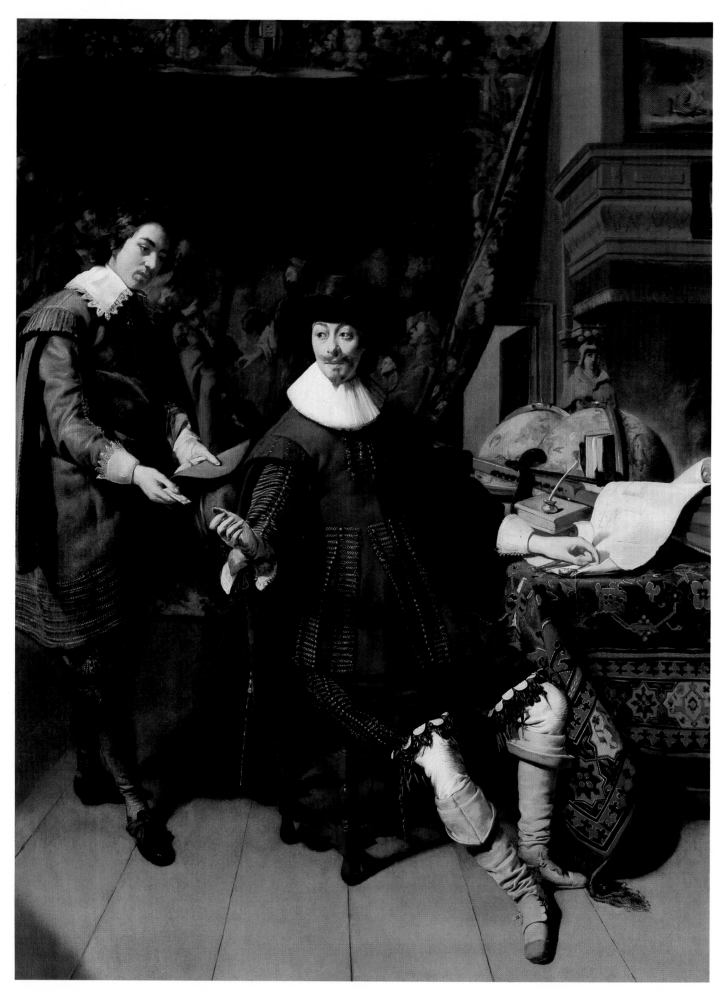

4. THOMAS DE KEYSER (1596/7–1667): *Constantijn Huygens and his Clerk*. 1627. London, National Gallery

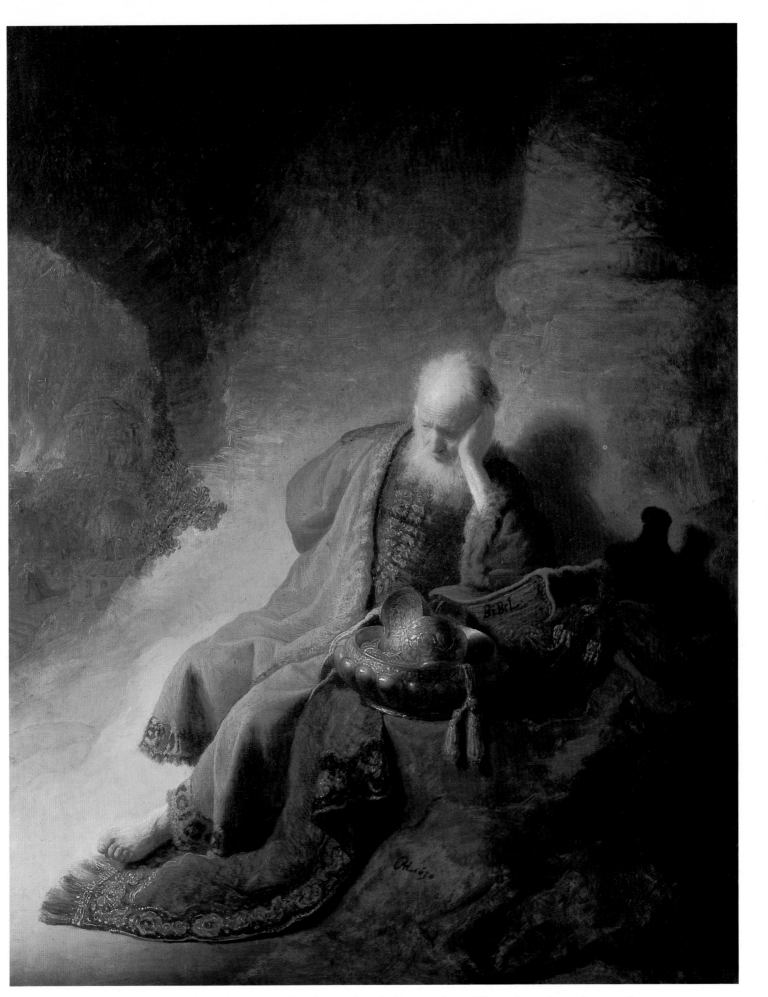

5. REMBRANDT VAN RIJN (1606–69): *Jeremiah Lamenting the Destruction of Jerusalem*. 1630. Amsterdam, Rijksmuseum

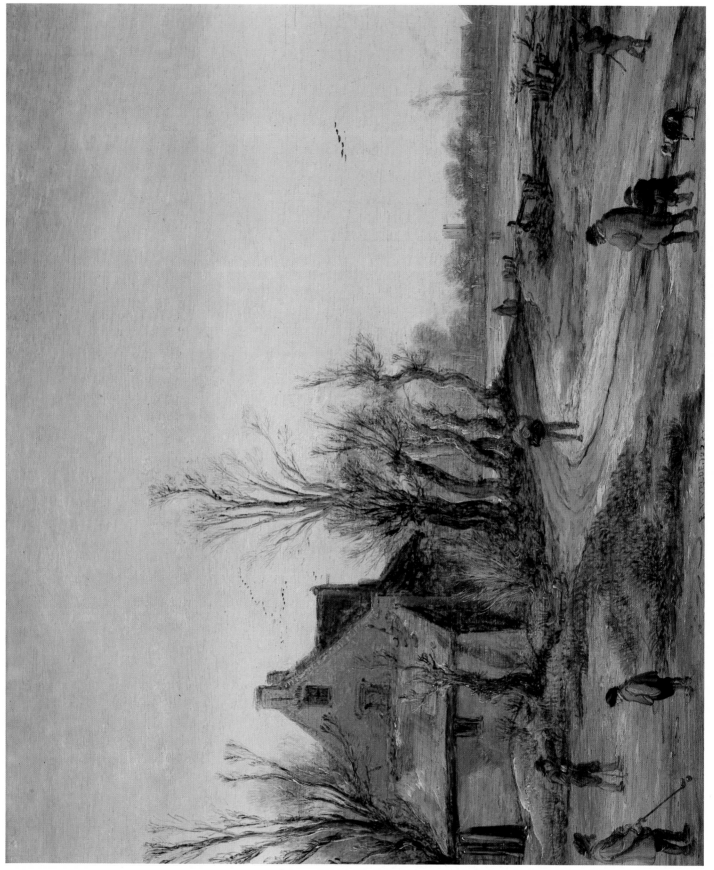

6. ESAIAS VAN DE VELDE (*c*.1590–1630) : *A Winter Landscape*. 1623. London, National Gallery

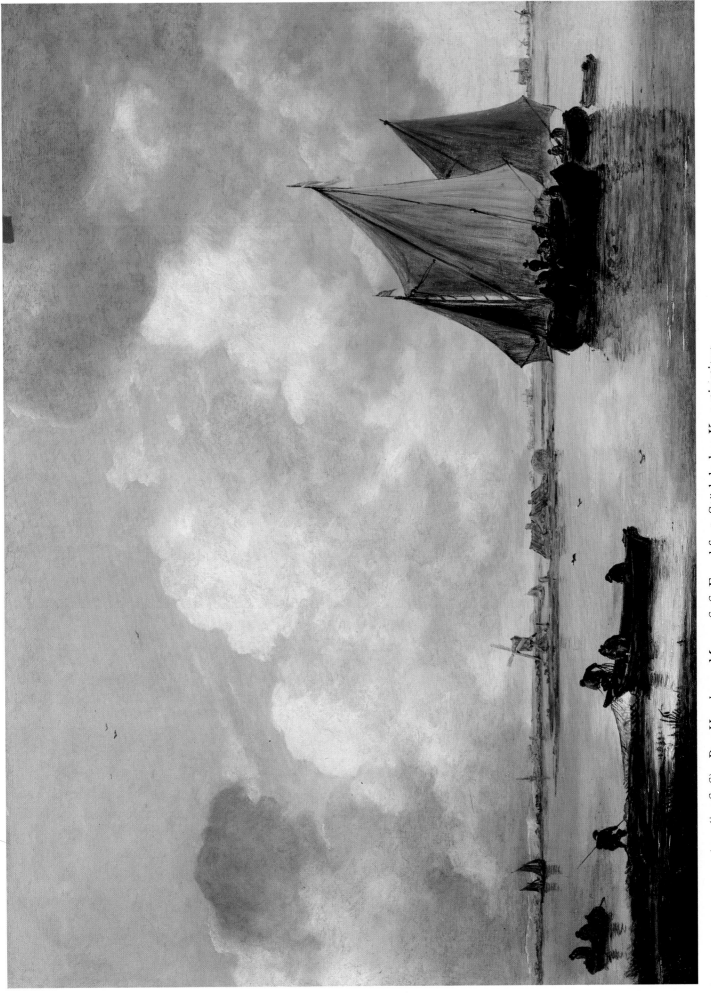

7. JAN VAN GOYEN (1596–1656) : *Das Haarlemer Meer.* 1656. Frankfurt, Städelsches Kunstinstitut

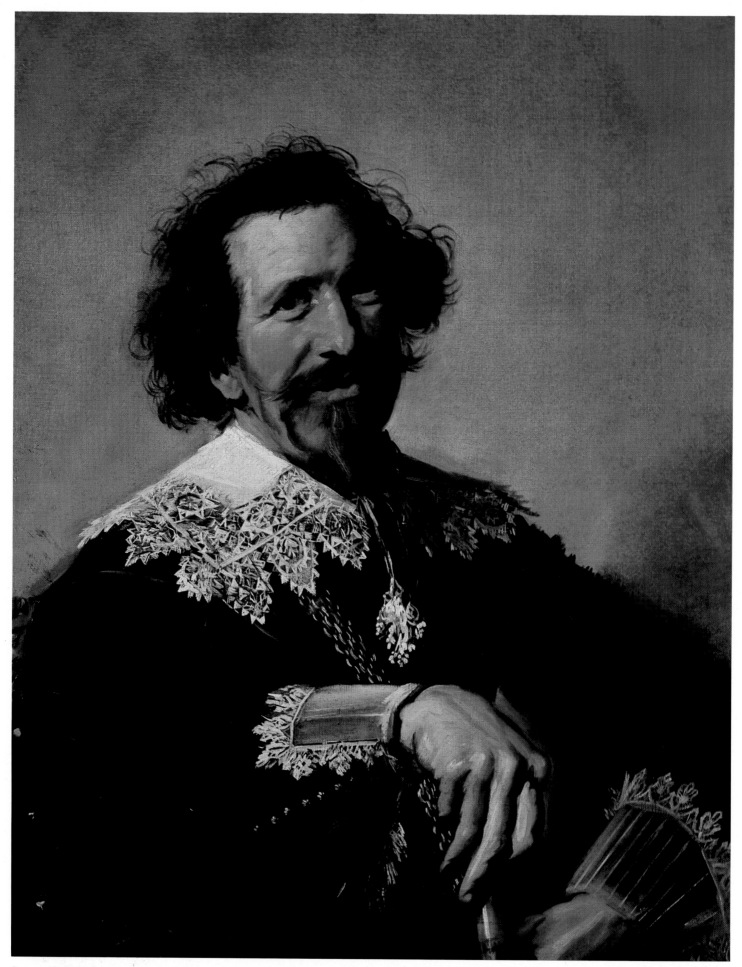

8. FRANS HALS (*c.*1580–1666): *Pieter van den Broecke*. About 1633. London, Kenwood House, Iveagh Bequest

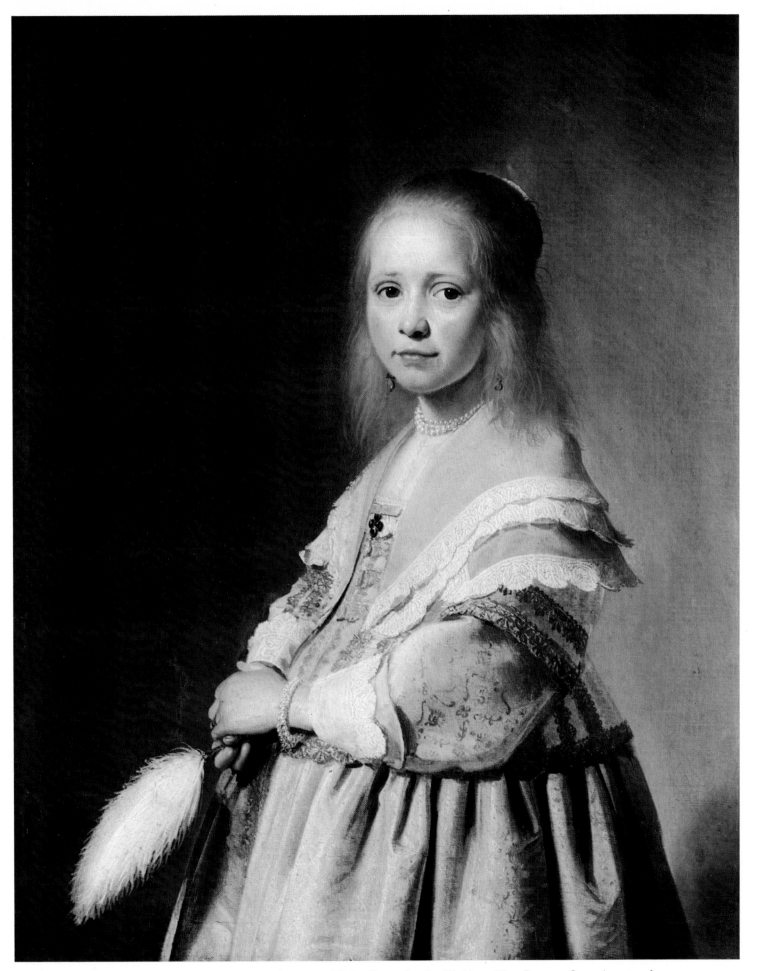

9. JOHANNES CORNELISZ. VERSPRONCK (1597–1662): *Portrait of a Girl in a Blue Dress*. 1641. Amsterdam, Rijksmuseum

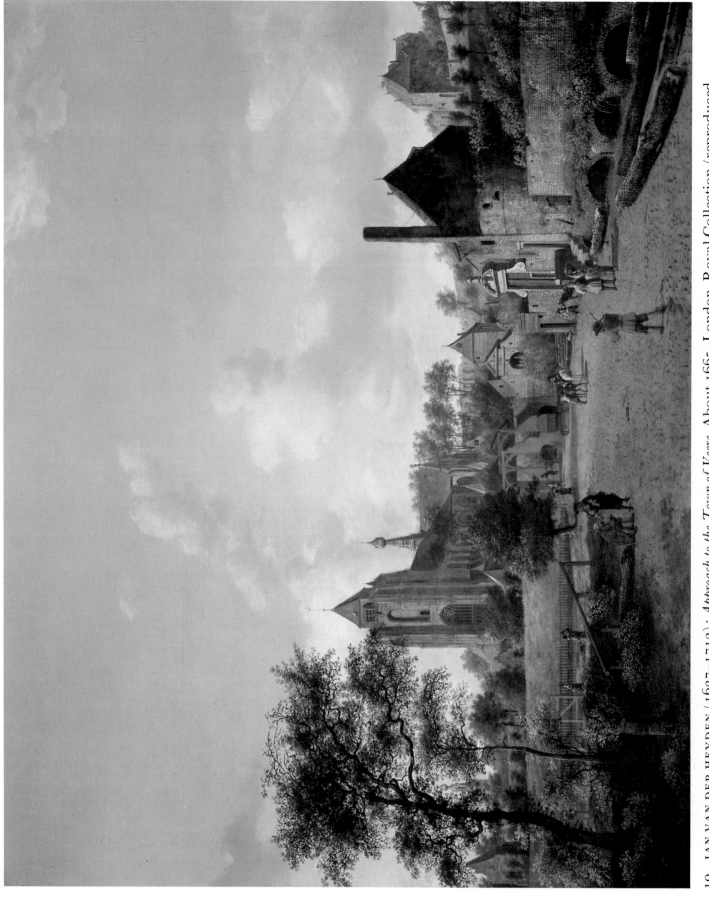

10. JAN VAN DER HEYDEN (1637–1712) : *Approach to the Town of Veere*. About 1665. London, Royal Collection (reproduced by gracious permission of Her Majesty the Queen)

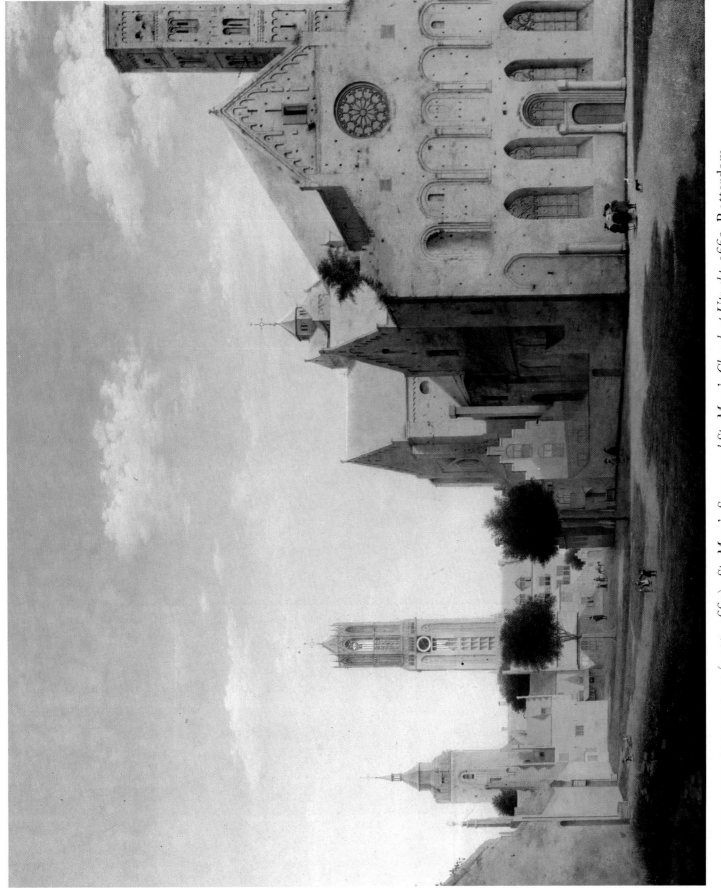

11. PIETER JANSZ. SAENREDAM (1597–1665): *St. Mary's Square and St. Mary's Church at Utrecht.* 1663. Rotterdam, Boymans-van Beuningen Museum

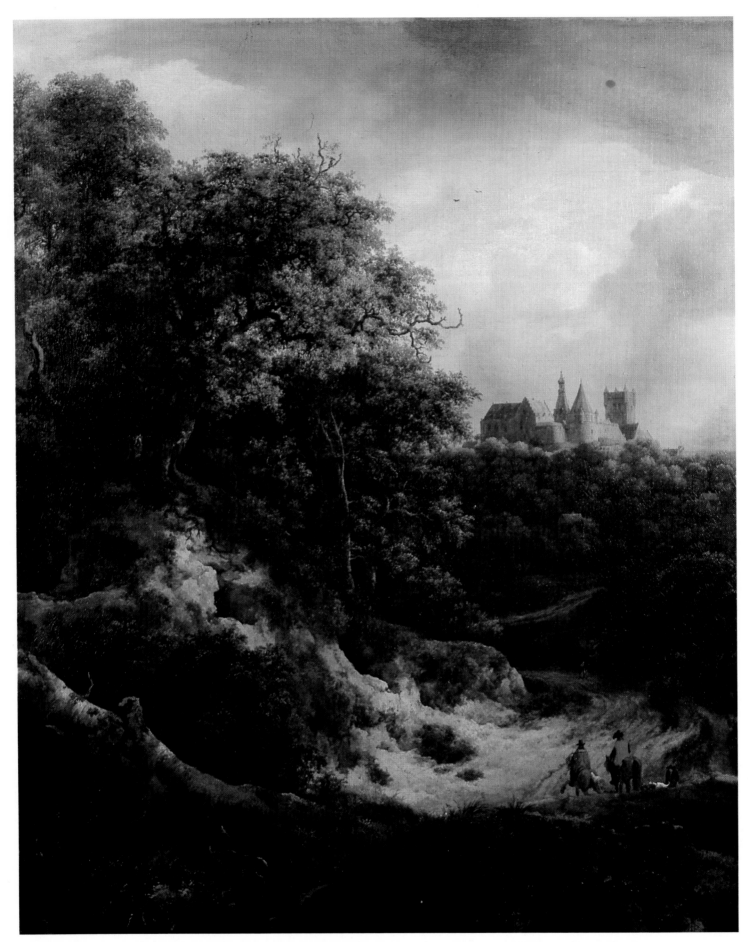

12. JACOB VAN RUISDAEL (1628/9–82): *The Castle at Bentheim*. 1651. England, Private Collection

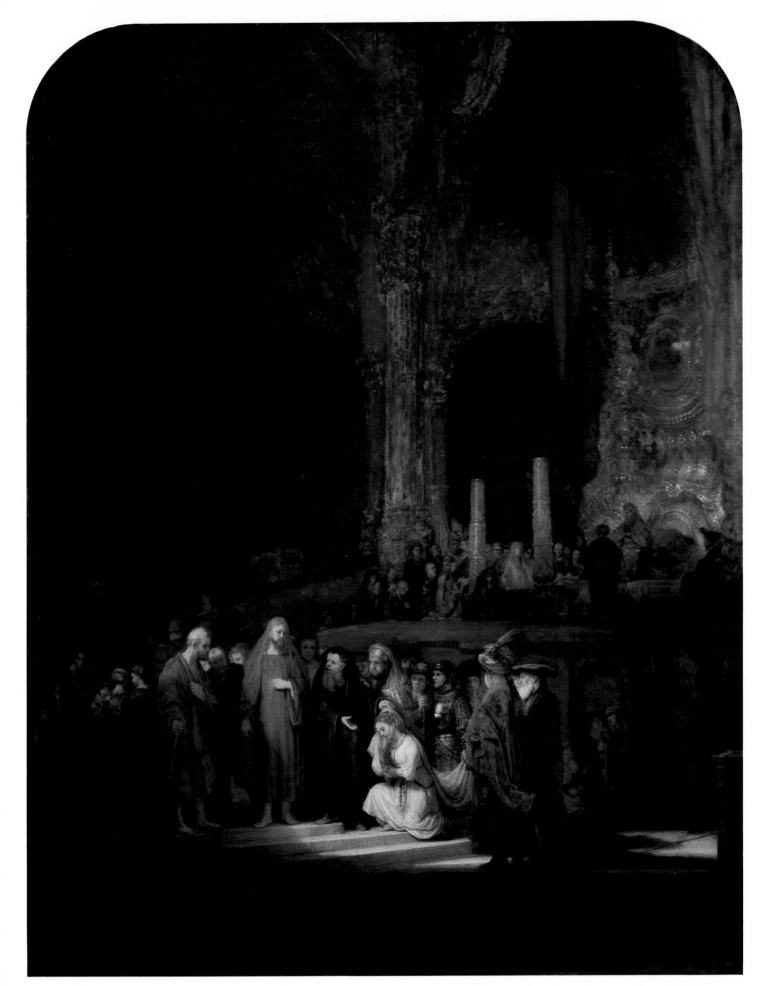

13. REMBRANDT VAN RIJN (1606–69): *Christ and the Woman Taken in Adultery*. 1644. London, National Gallery

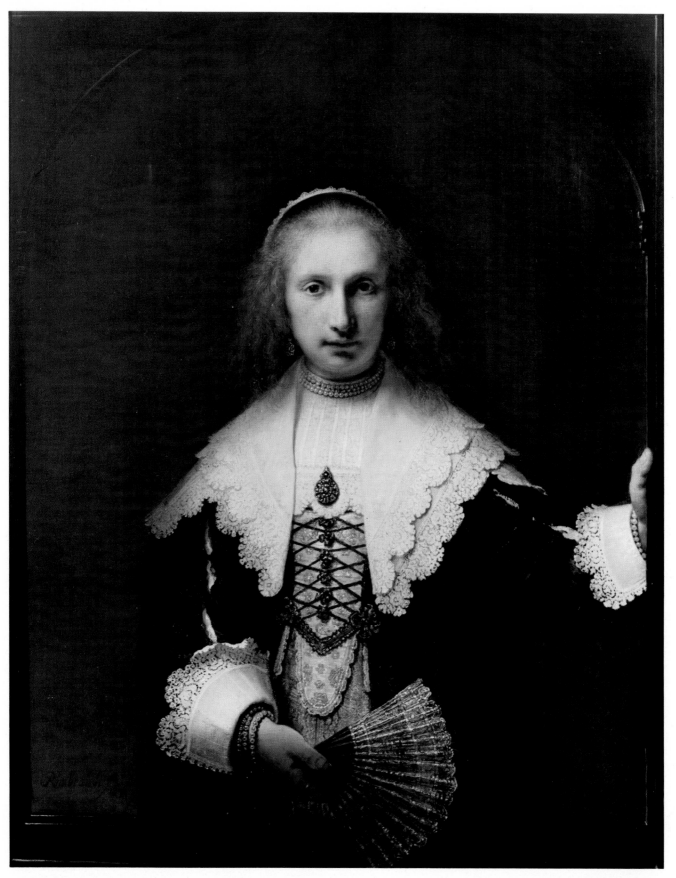

14. REMBRANDT VAN RIJN (1606–69): *Agatha Bas*. 1641. London, Royal Collection (reproduced by gracious permission of Her Majesty the Queen)

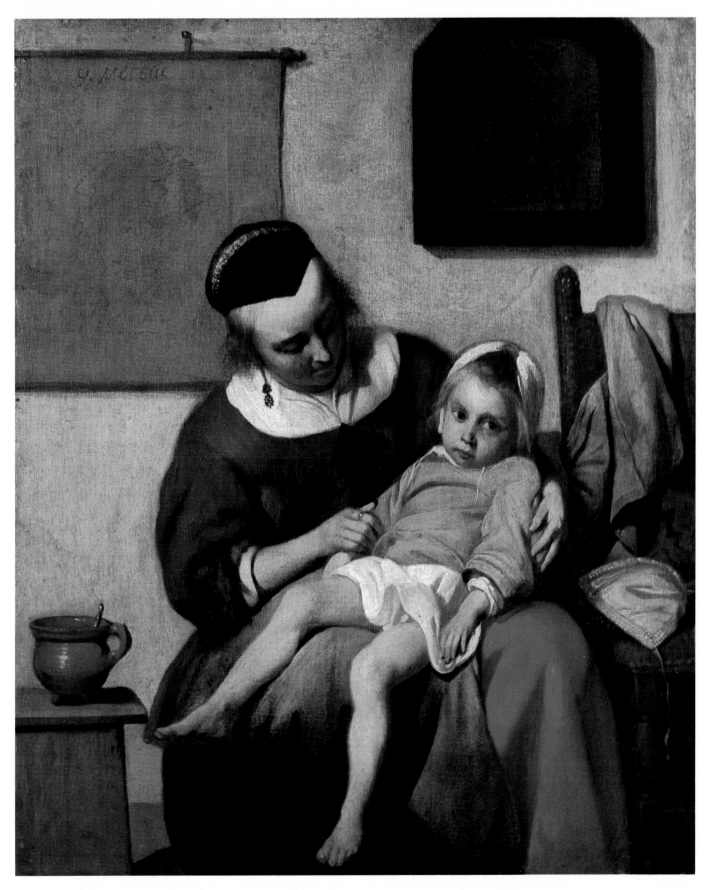

15. GABRIEL METSU (1629–67): *The Sick Child.* About 1600. Amsterdam, Rijksmuseum

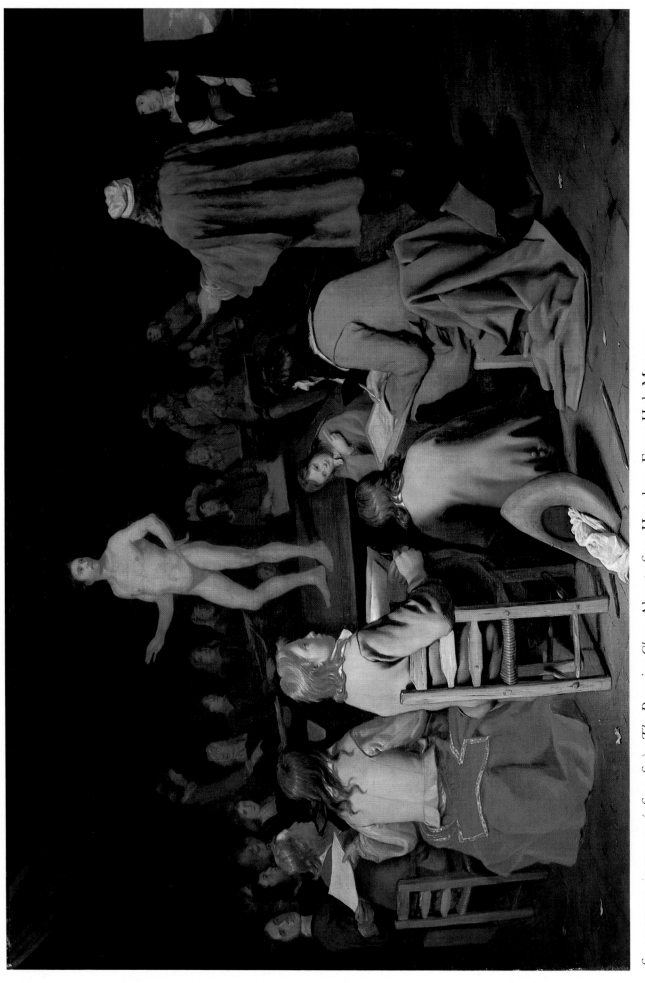

16. MICHIEL SWEERTS (1624–64) : *The Drawing Class.* About 1650. Haarlem, Frans Hals Museum

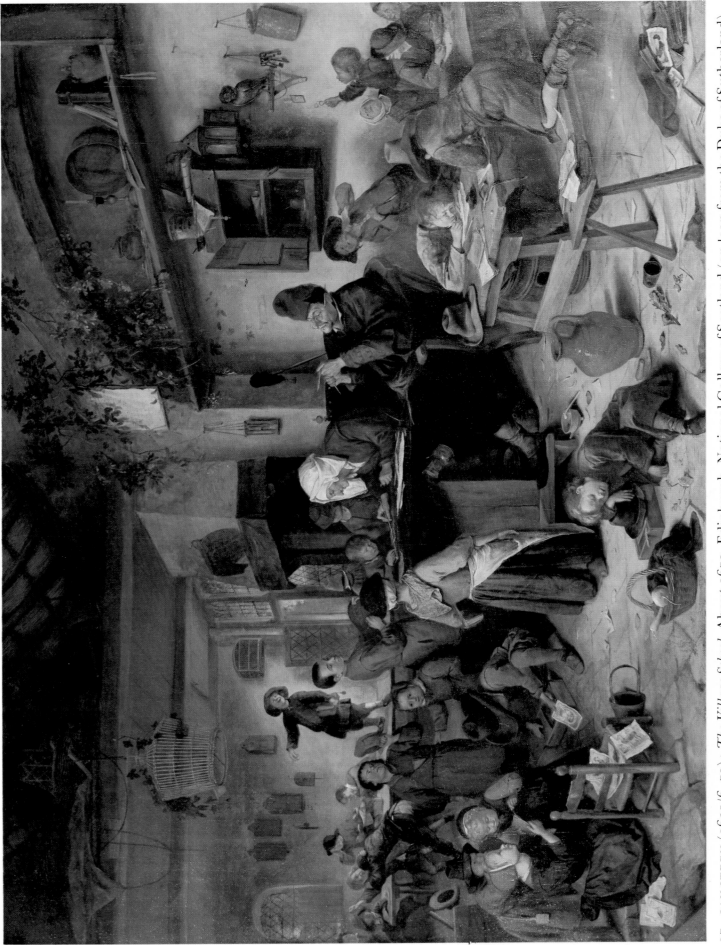

17. JAN STEEN (1625/6–79): *The Village School*. About 1670. Edinburgh, National Gallery of Scotland (on loan from the Duke of Sutherland)

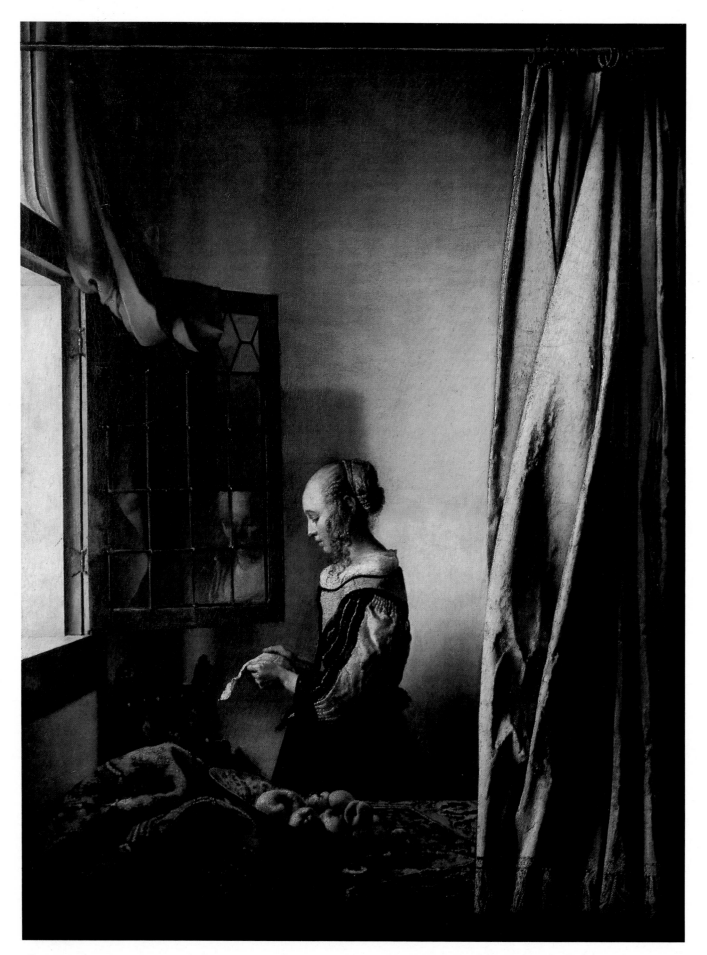

18. JOHANNES VERMEER (1632–75): *A Girl Reading at an Open Window*. About 1658. Dresden, Gemäldegalerie

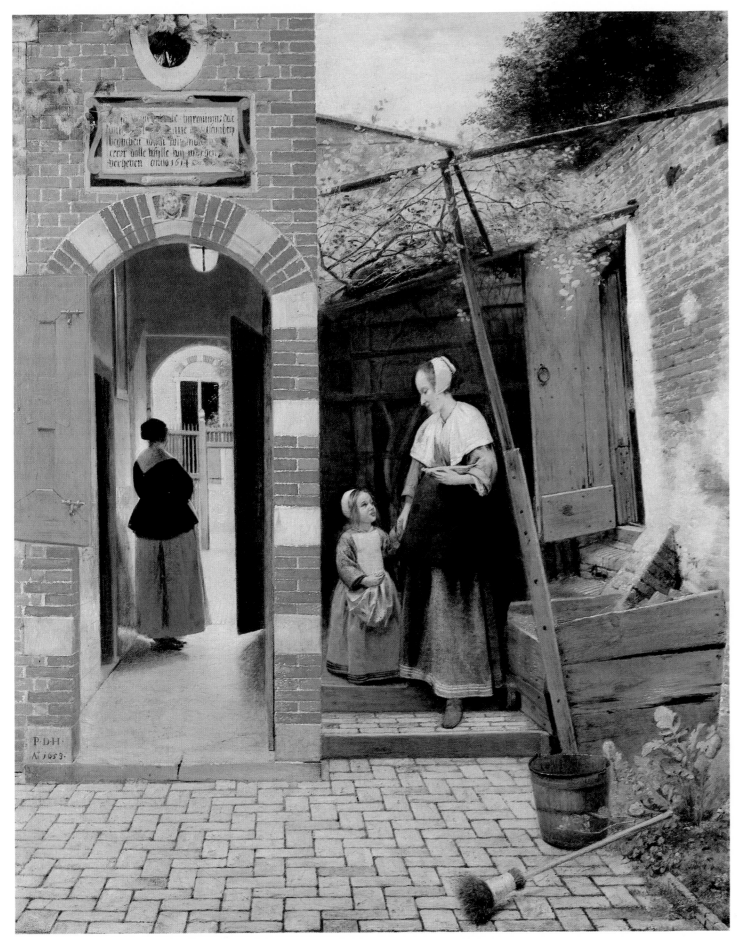

19. PIETER DE HOOGH (1629–after 1684): *The Courtyard of a House in Delft*. 1658. London, National Gallery

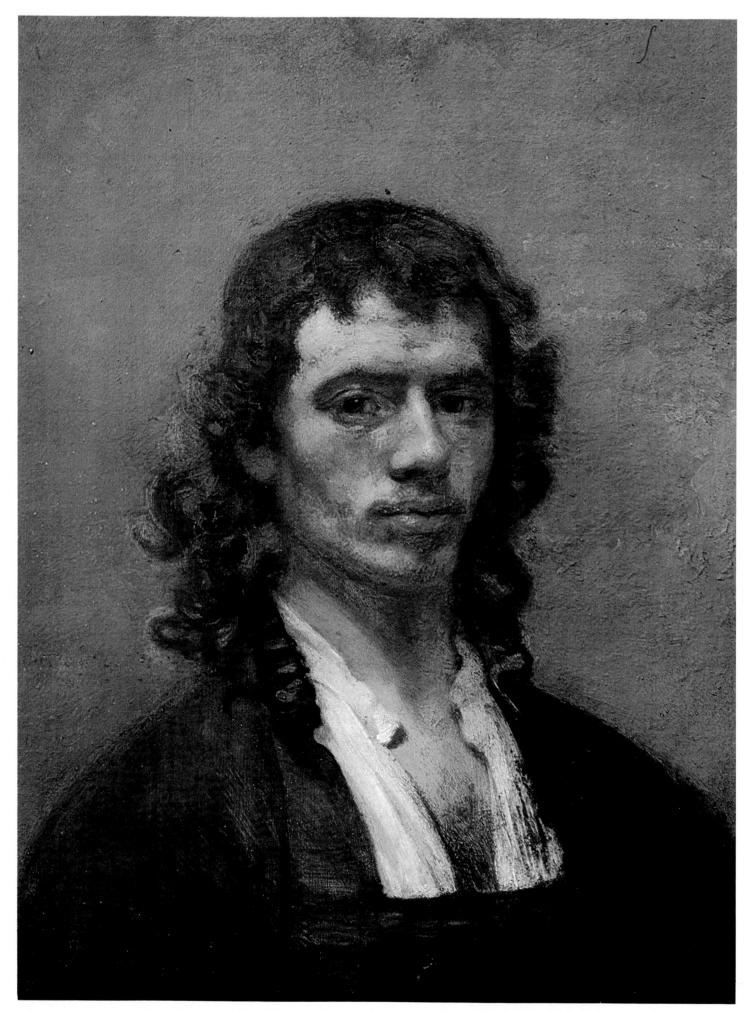

20. CAREL FABRITIUS (1622–54): *Self-Portrait*. About 1654. Rotterdam, Boymans-van Beuningen Museum

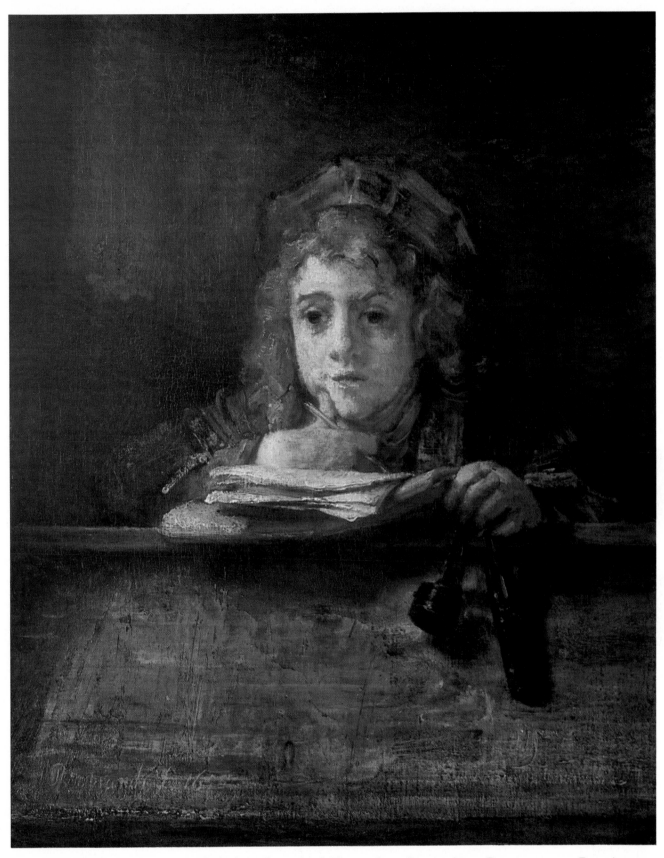

21. REMBRANDT VAN RIJN (1606–69): *Portrait of Titus*. 1655. Rotterdam, Boymans-van Beuningen Museum

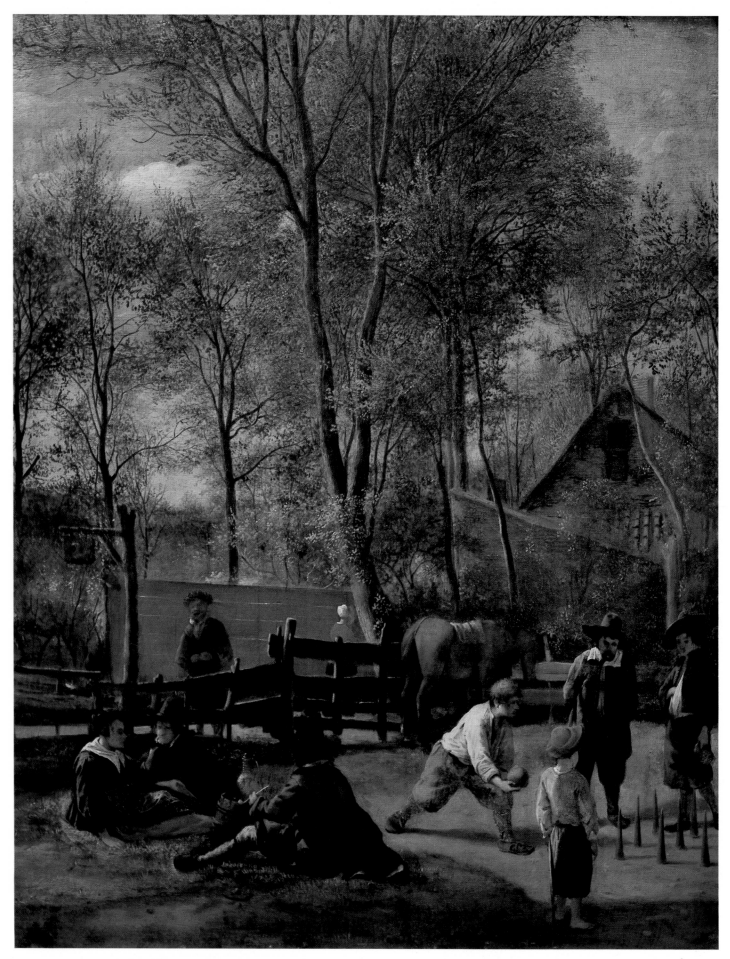

22. JAN STEEN (1625/6–79) *Skittle Players outside an Inn.* About 1662–3. London, National Gallery

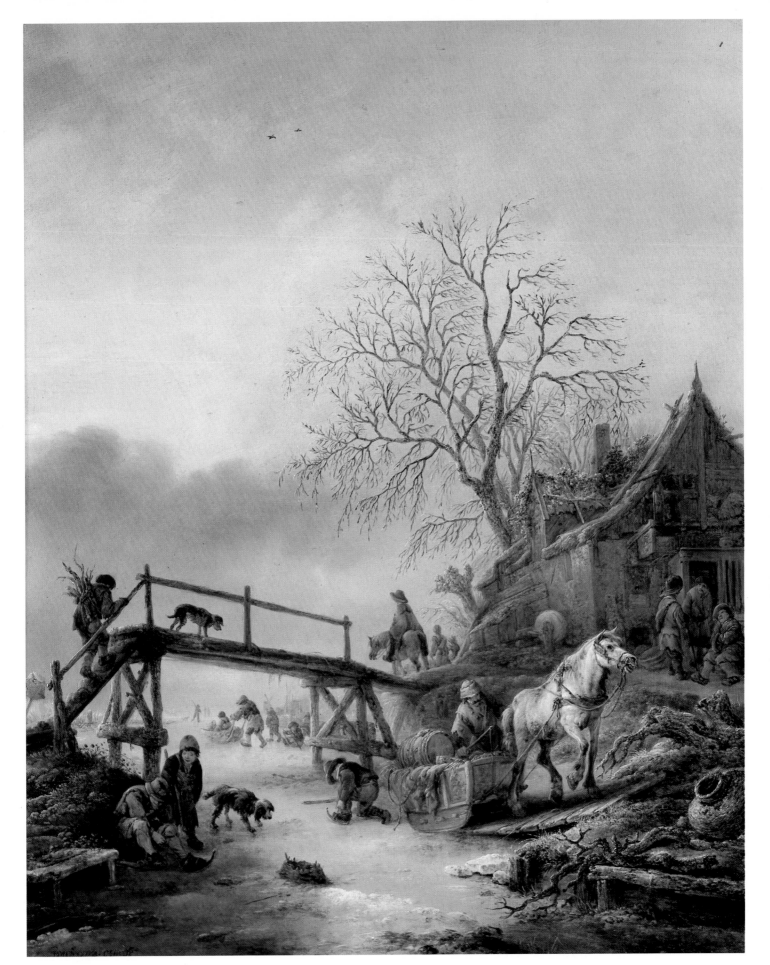

23. ISACK VAN OSTADE (1621–49): *A Winter Scene*. About 1645. London, National Gallery

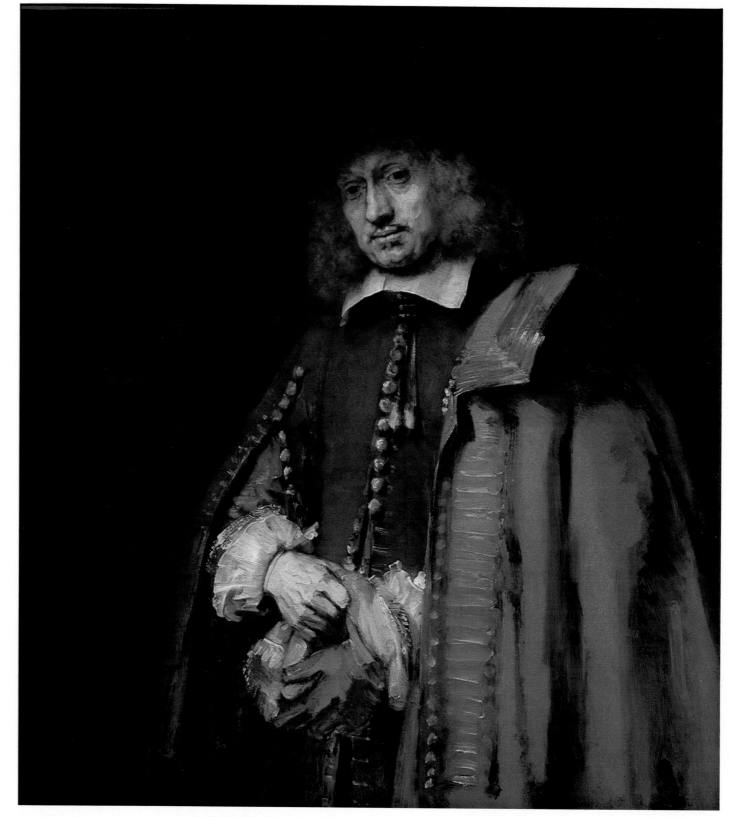

24. REMBRANDT VAN RIJN (1606–69): *Jan Six*. 1654. Amsterdam, Six Collection

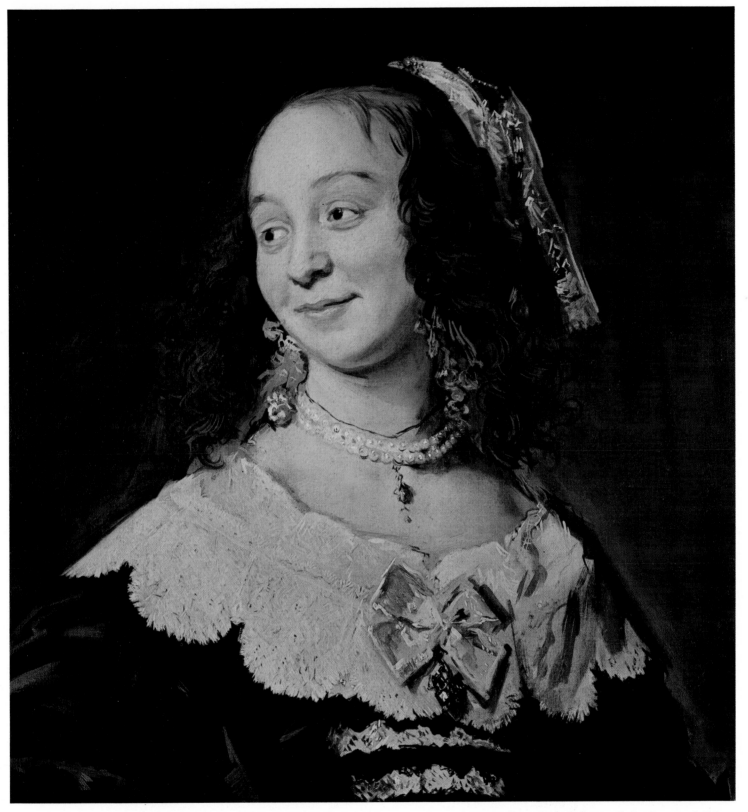

25. FRANS HALS (*c.*1580–1666): *Isabella Coymans*. Detail. About 1650–2. Paris, Baronne Edouard de Rothschild

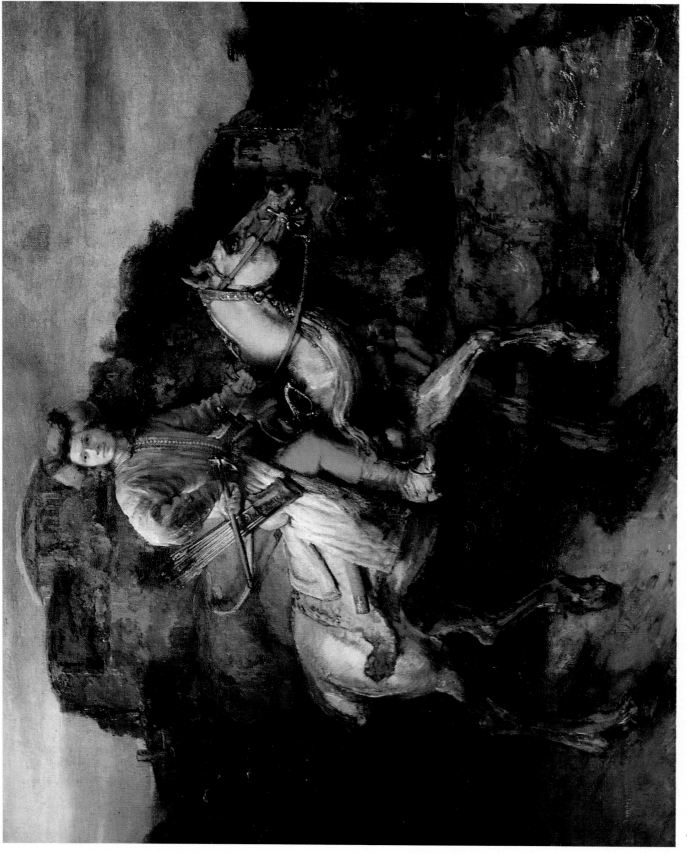

26. REMBRANDT VAN RIJN (1606–69) : 'The Polish Rider'. About 1655. New York, Frick Collection

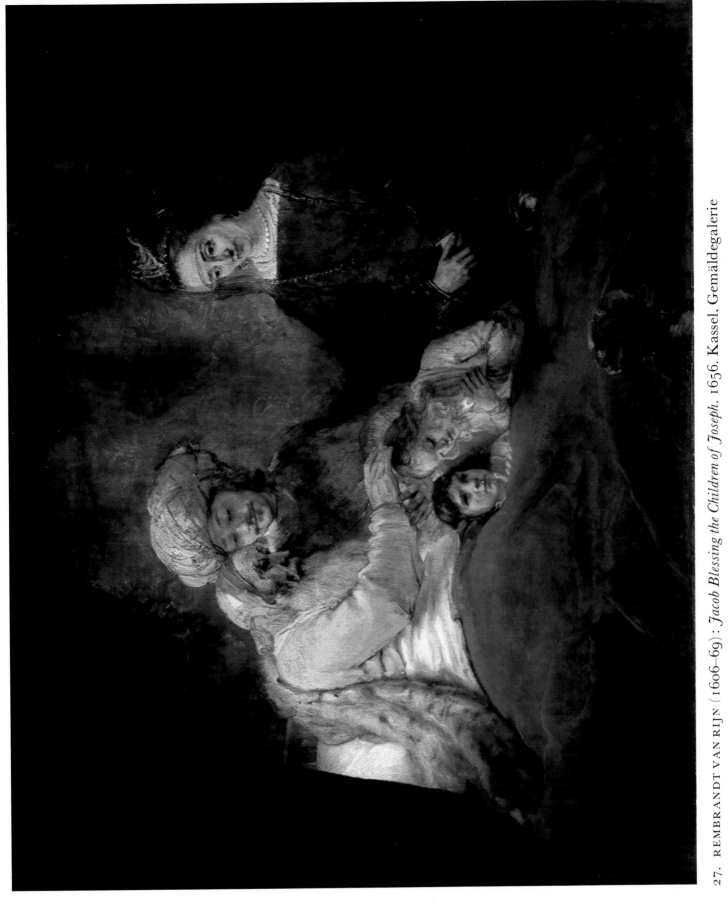

27. REMBRANDT VAN RIJN (1606–69) : *Jacob Blessing the Children of Joseph.* 1656. Kassel, Gemäldegalerie

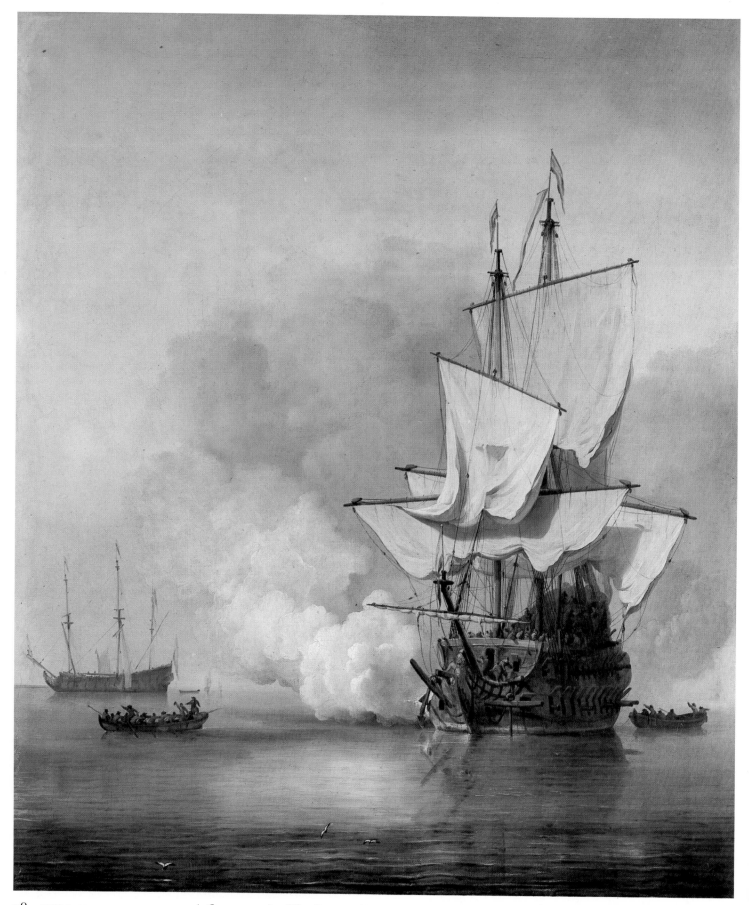

28. WILLEM VAN DE VELDE (1633–1707): *The Cannon Shot*. About 1670. Amsterdam, Rijksmuseum

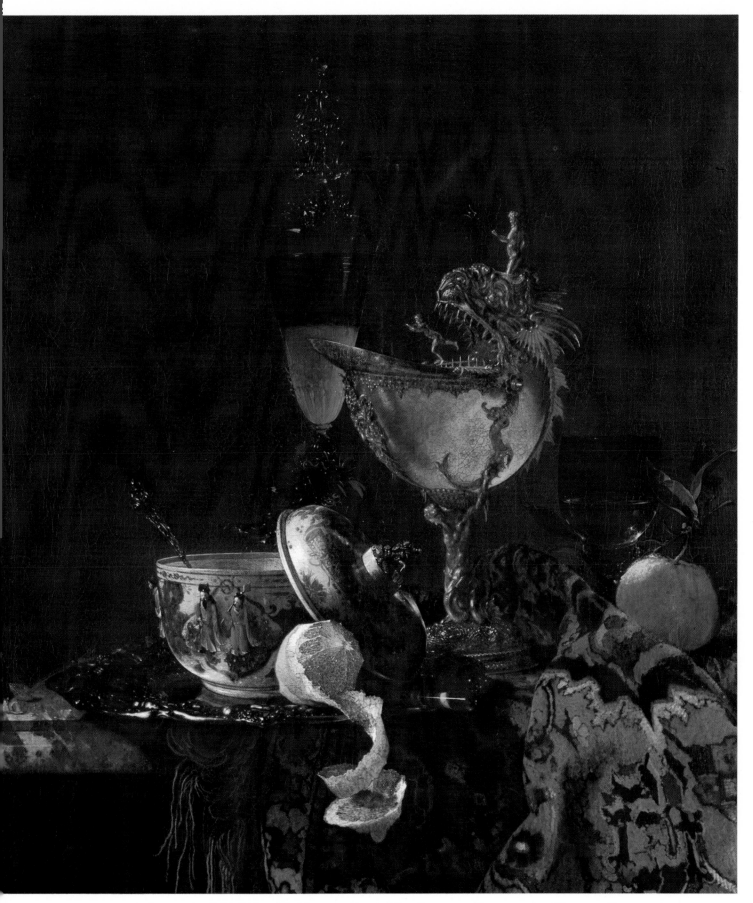

29. WILLEM KALF (1619–93): *Still-Life with Nautilus Cup.* 1662. Lugano-Castagnola, Thyssen-Bornemisza Collection

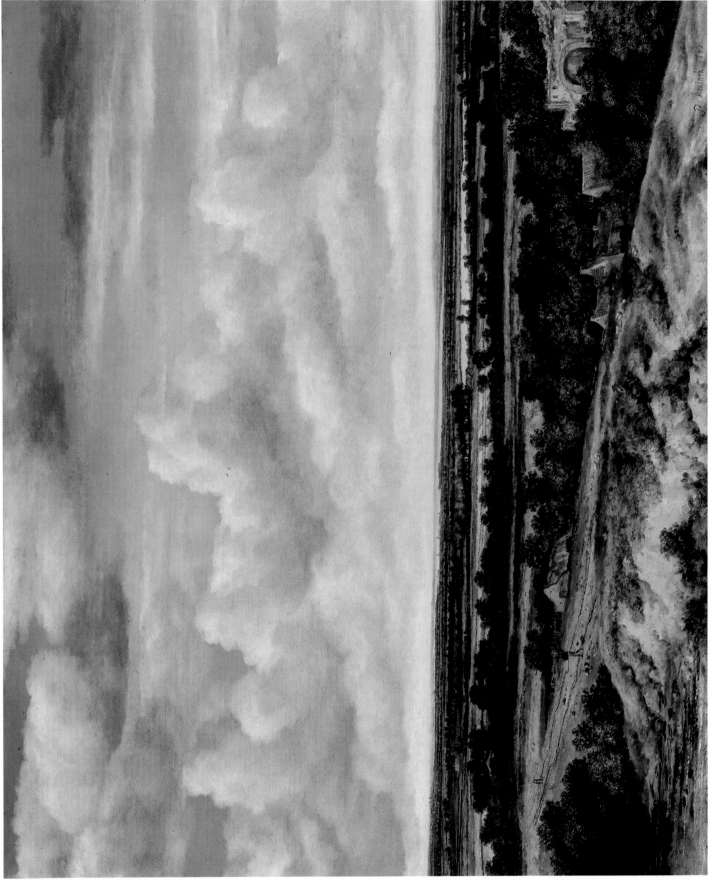

30. PHILIPS KONINCK (1619–88) : *An Extensive Landscape with a Road by a Ruin.* 1655. London, National Gallery

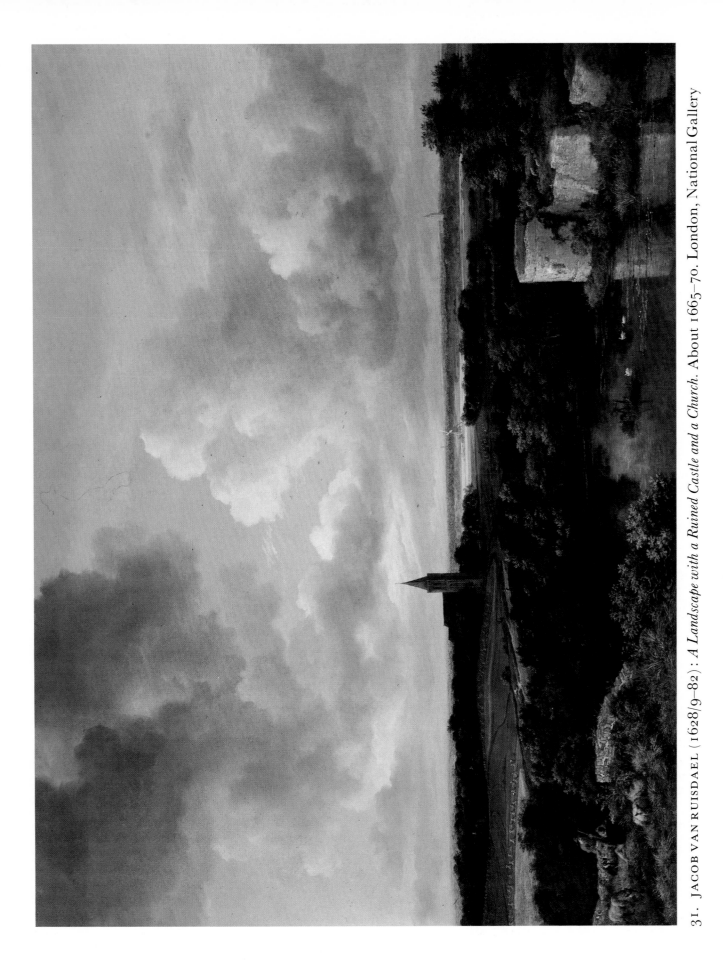

31. JACOB VAN RUISDAEL (1628/9–82) : *A Landscape with a Ruined Castle and a Church. About 1665–70. London, National Gallery*

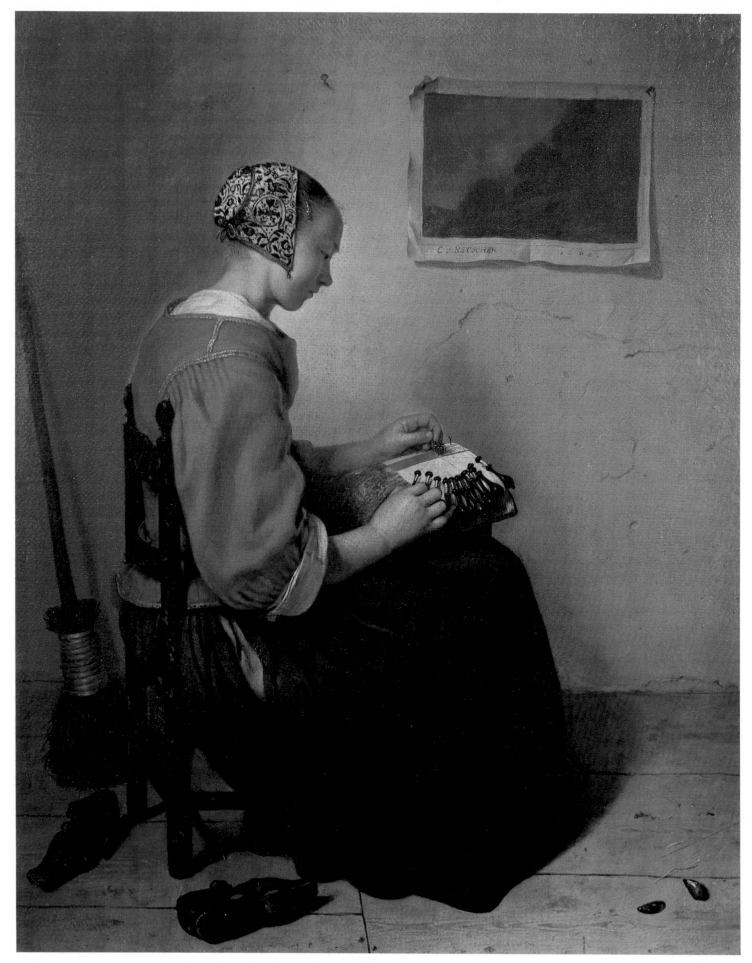

32. CASPAR NETSCHER (1639–84): *The Lace-Maker*. 1664. London, Wallace Collection

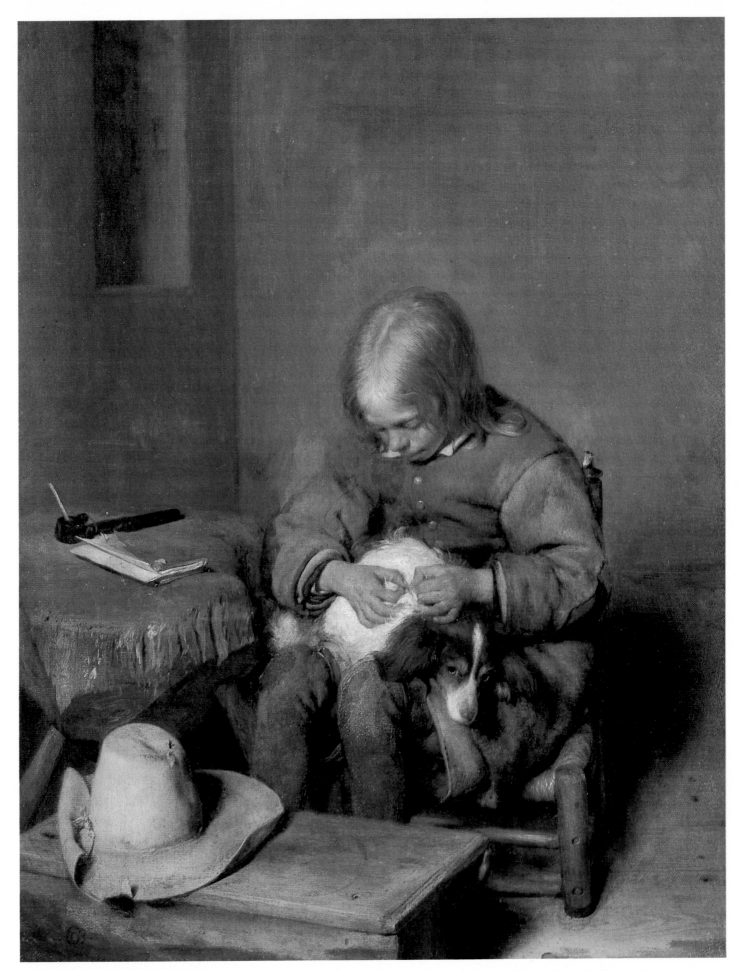

33. GERARD TER BORCH (1617–81): *A Boy Ridding his Dog of Fleas*. About 1665. Munich, Bayerische Staatsgemäldesammlungen

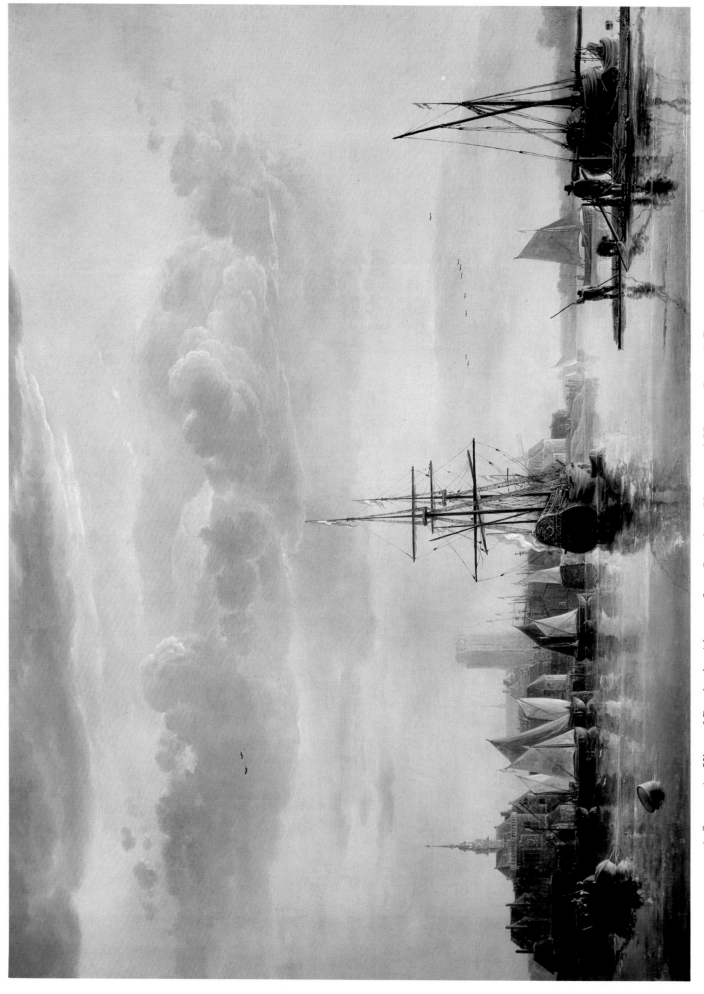

34. AELBERT CUYP (1620—91): *View of Dordrecht.* About 1655. London, Kenwood House, Iveagh Bequest

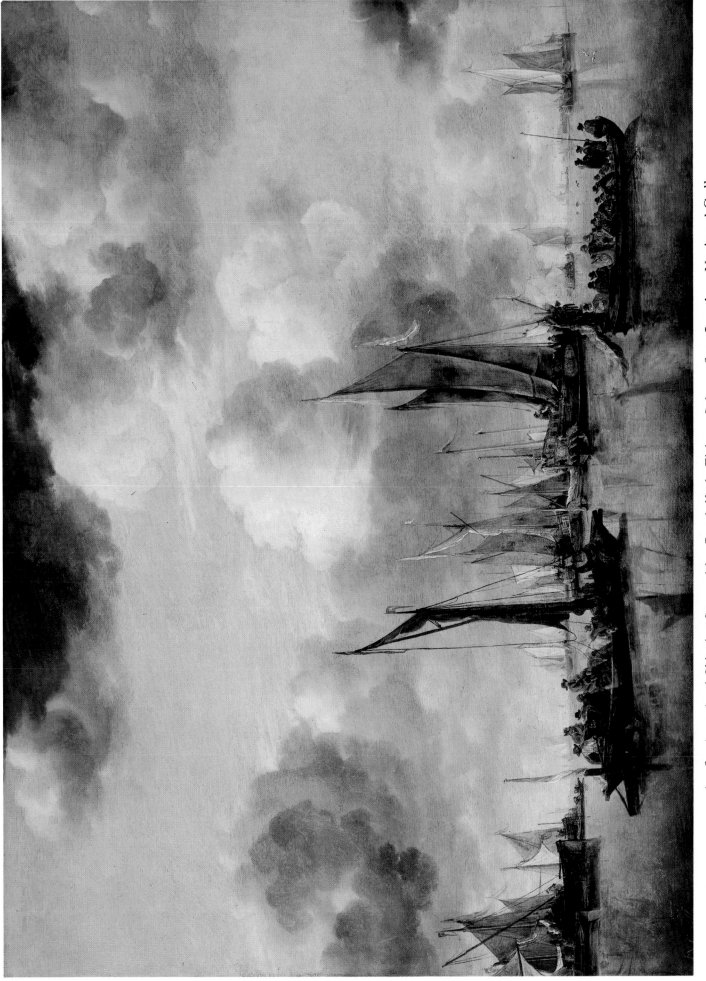

35. JAN VAN DE CAPPELLE (*c.* 1623/5-79) : *A Shipping Scene with a Dutch Yacht Firing a Salute.* 1650. London, National Gallery

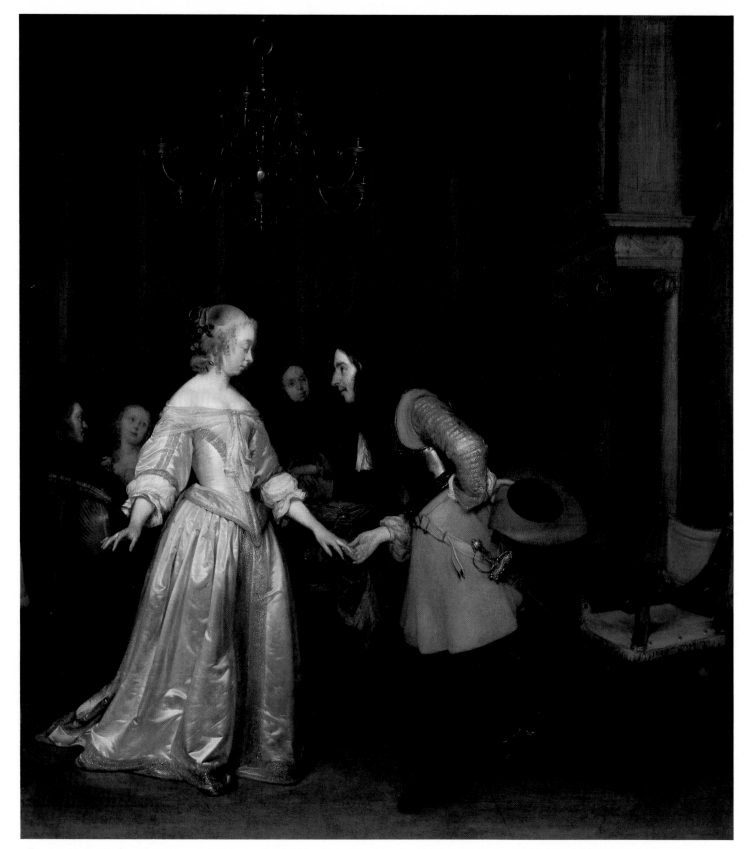

36. GERARD TER BORCH (1617–81): *A Dancing Couple*. About 1662. Polesden Lacey, The National Trust

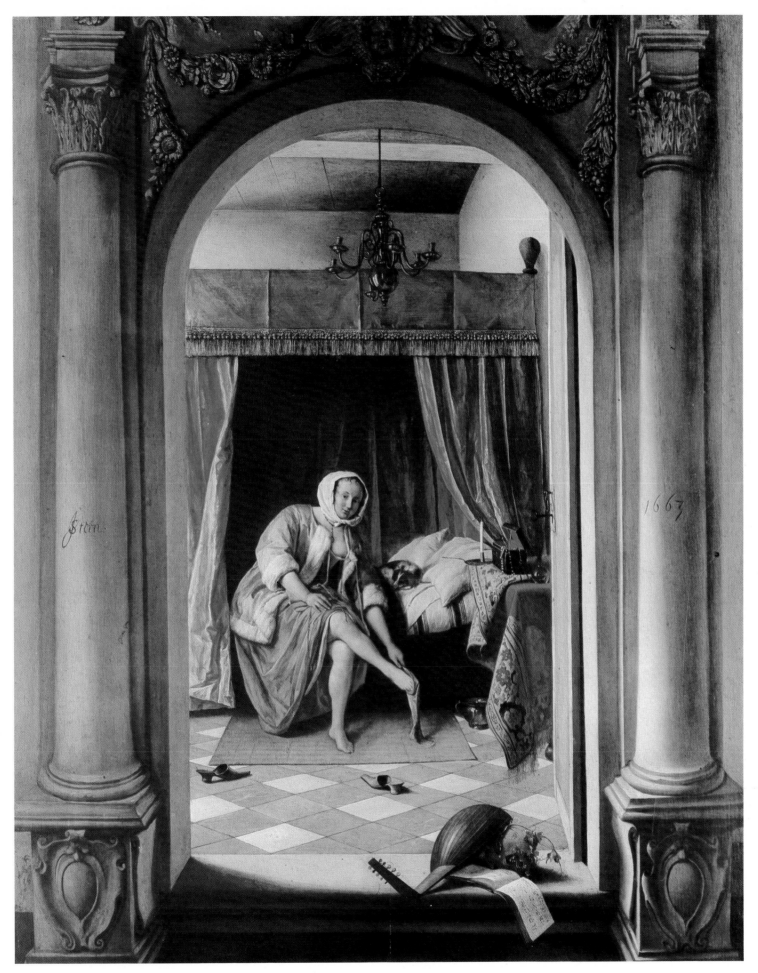

37. JAN STEEN (1625/6–79): *The Morning Toilet*. 1663. London, Royal Collection (reproduced by gracious permission of Her Majesty the Queen)

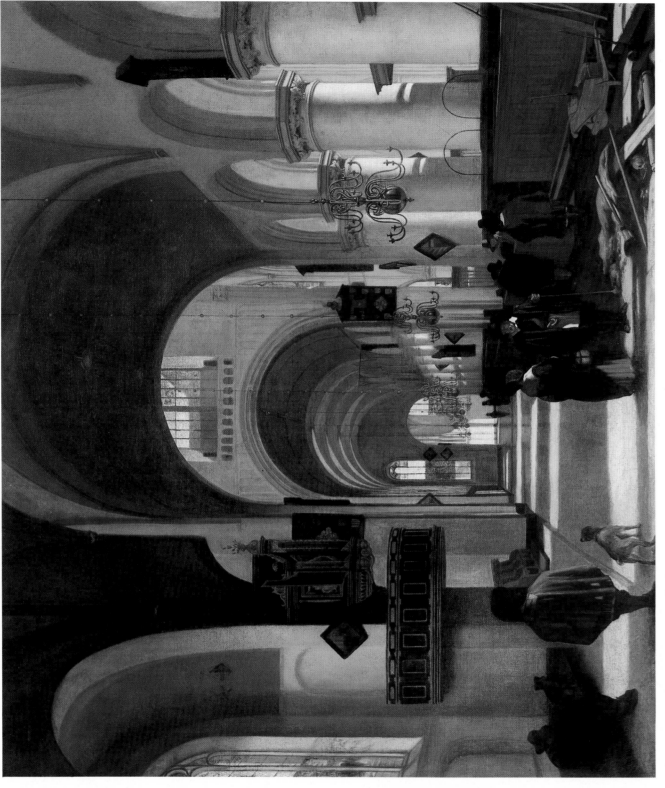

38. EMANUEL DE WITTE (1616/18–92) : *Interior of a Protestant Gothic Church.* 1668. Rotterdam, Boymans-van Beuningen Museum

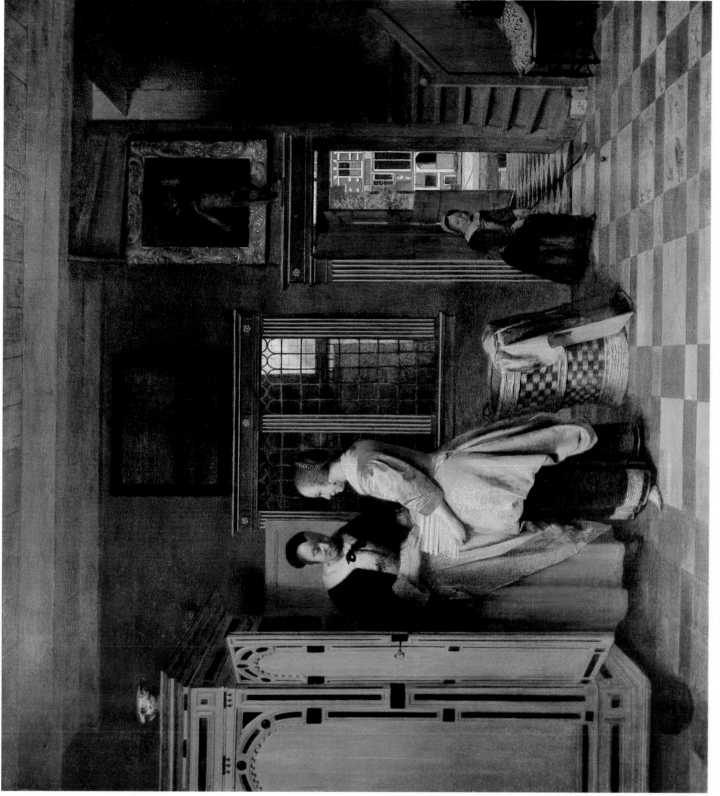

39. PIETER DE HOOGH (1629–after 1684) : *At the Linen Closet*. 1663. Amsterdam, Rijksmuseum

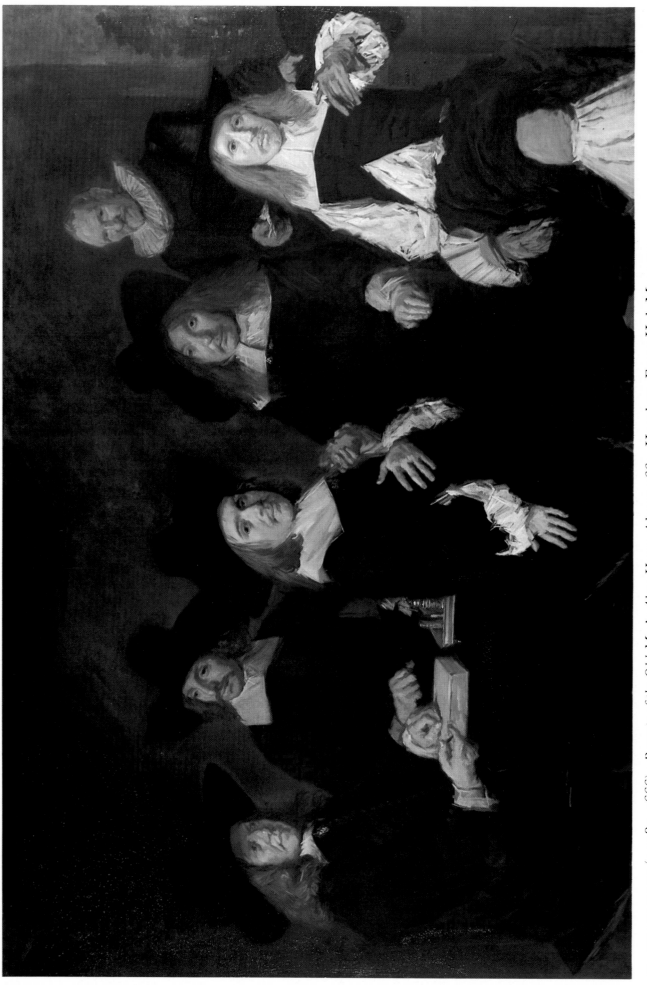

40. FRANS HALS (*c.* 1580–1666) : *Regents of the Old Men's Alms House. About* 1664. Haarlem, Frans Hals Museum

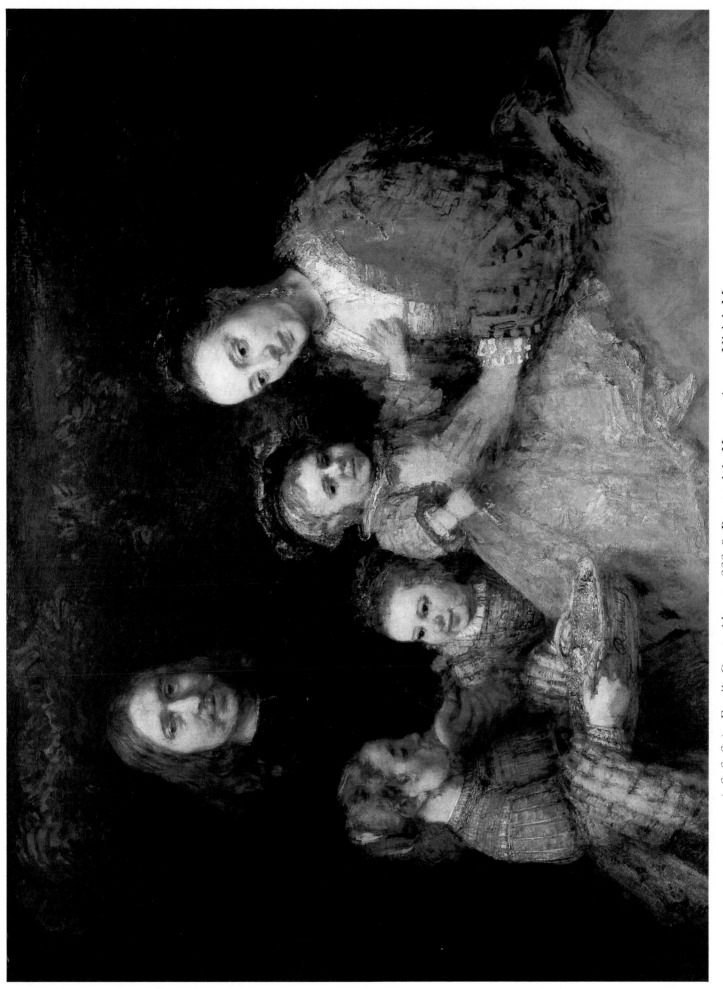

41. REMBRANDT VAN RIJN (1606–69) : *Family Group*. About 1666–8. Brunswick, Herzog Anton Ulrich Museum

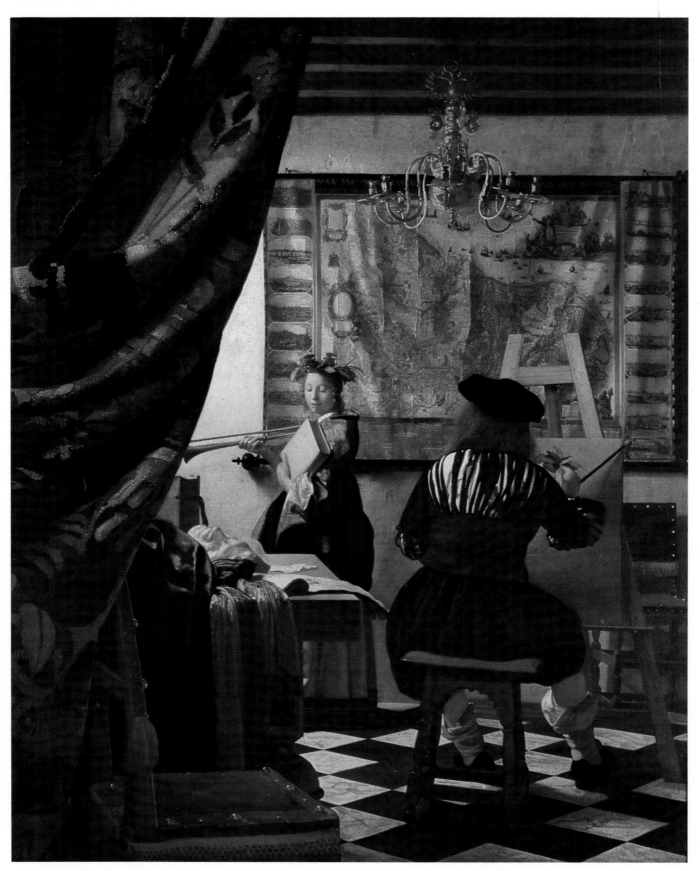

42. JOHANNES VERMEER (1632–75): *A Painter in his Studio*. About 1666. Vienna, Kunsthistorisches Museum

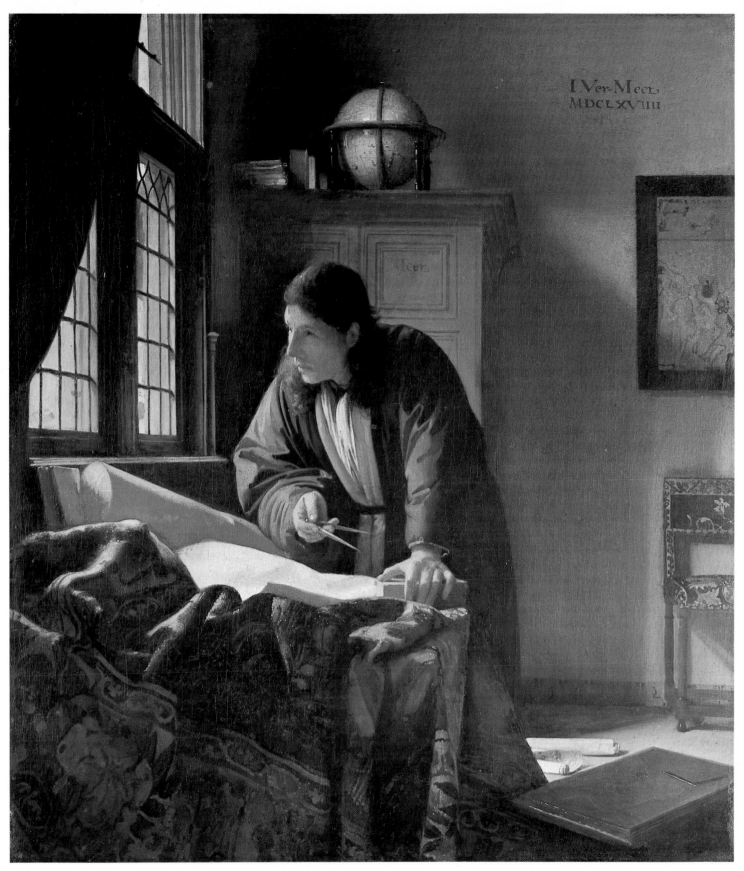

43. JOHANNES VERMEER (1632–75): *The Geographer.* 1669. Frankfurt, Städelsches Kunstinstitut

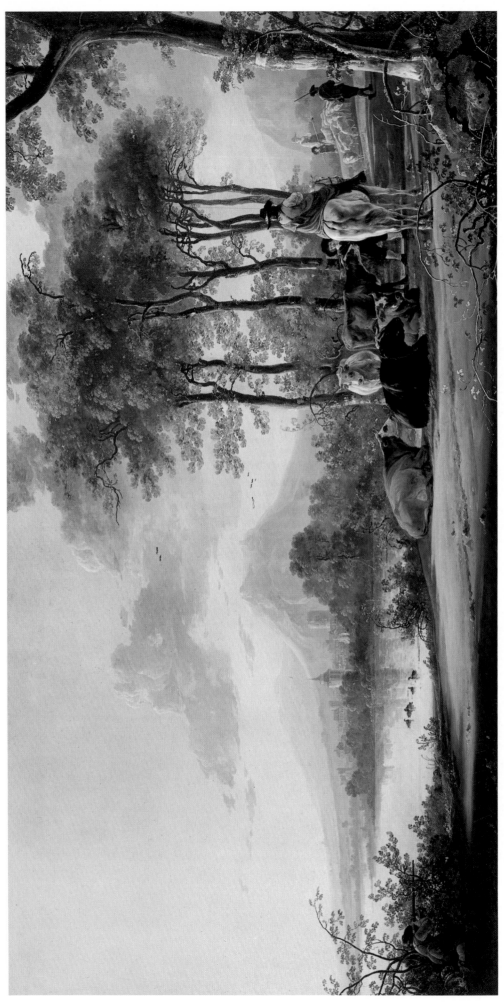

44. AELBERT CUYP (1620–91) : *River Landscape*. About 1655–60. Mount Stuart, Marquess of Bute

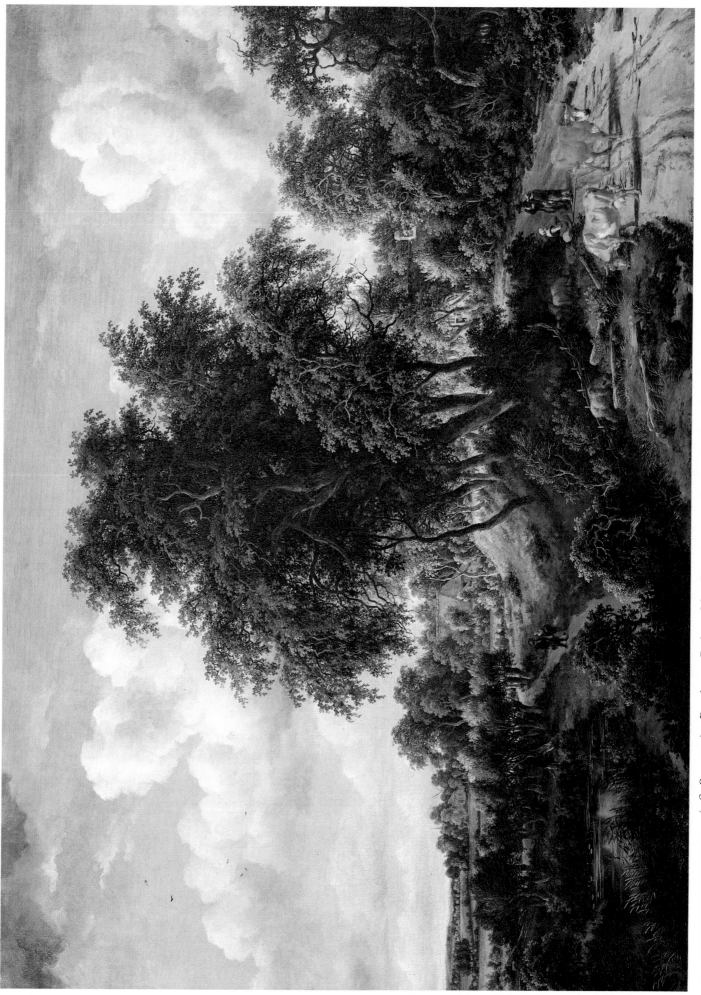

45. MEYNDERT HOBBEMA (1638–1709): *Road on a Dyke*. 1663. Blessington, Ireland, Sir Alfred Beit, Bt.

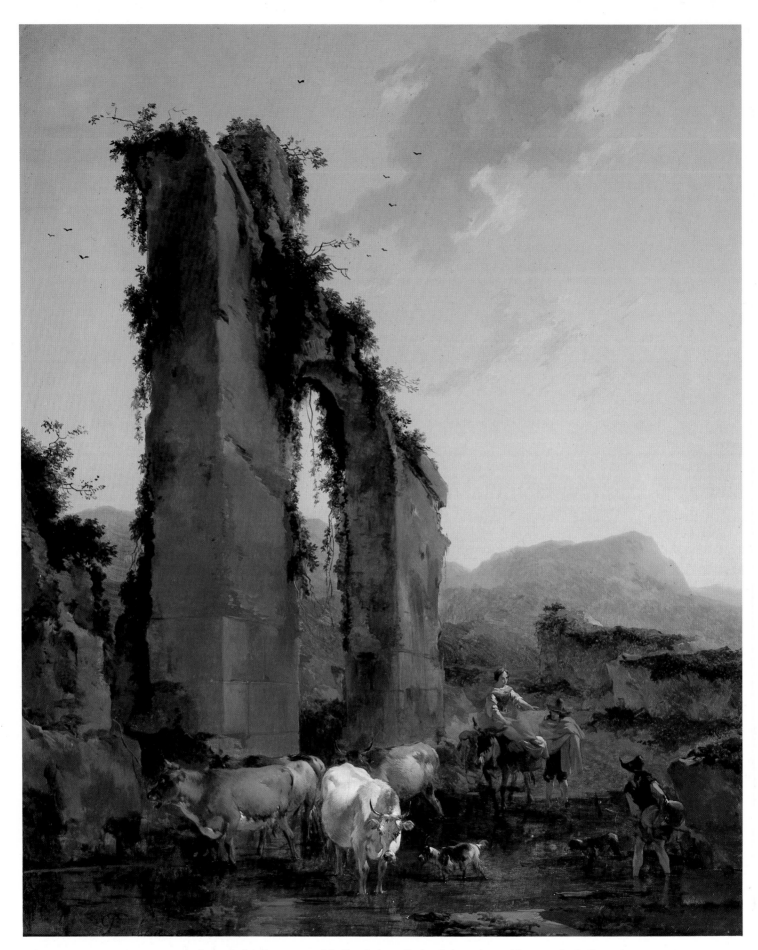

46. NICOLAES BERCHEM (1620–83): *Peasants with Cattle by a Ruined Aqueduct*. About 1658. London, National Gallery

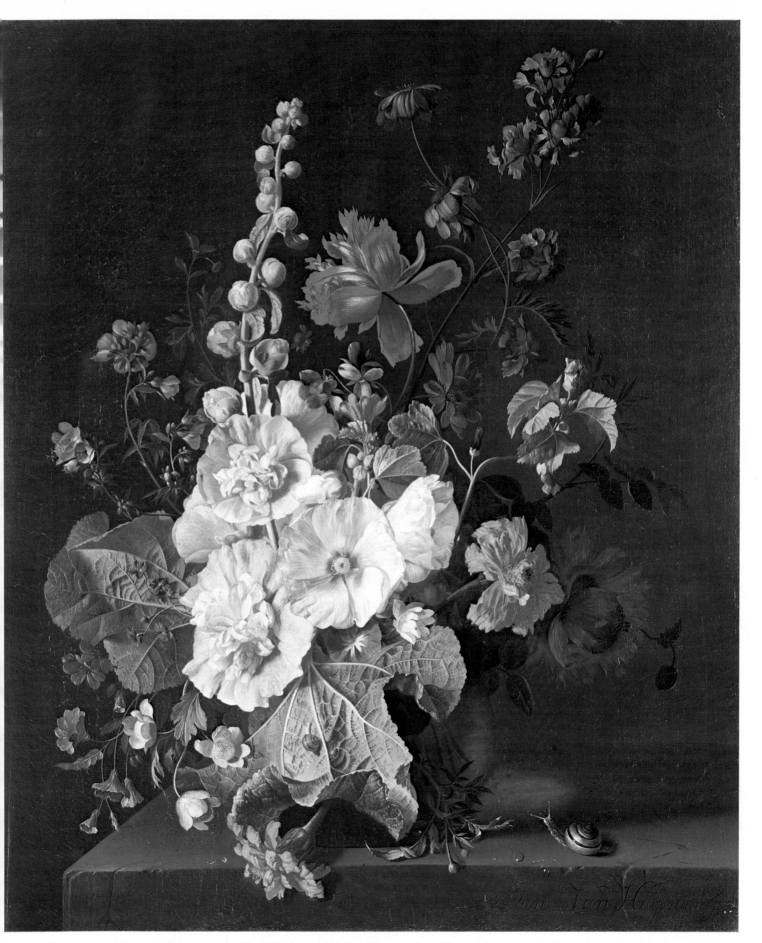

47. JAN VAN HUIJSUM (1682–1749): *Hollyhocks and Other Flowers in a Vase.* About 1710. London, National Gallery

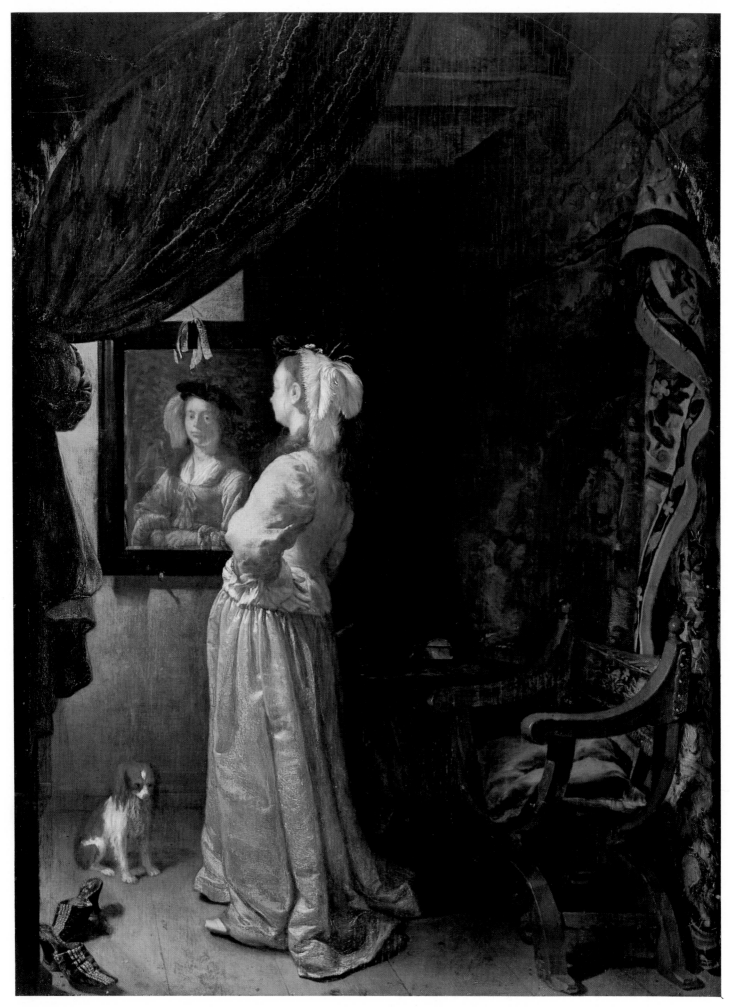

48. FRANS VAN MIERIS (1635–81): *A Lady Looking into a Mirror*. About 1662–3. Munich, Alte Pinakothek